Digital Photography
Click-by-Click

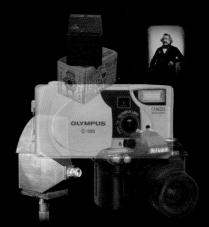

Digital Photography
Click-by-Click

Jerry Glenwright

FRIEDMAN/FAIRFAX
P U B L I S H E R S

A Friedman / Fairfax Book

Friedman / Fairfax Publishers

Please visit our website: *www.metrobooks.com*

This edition published by Friedman / Fairfax by
arrangement with The Ilex Press Limited

2002 Friedman/Fairfax Publishers

Copyright © 2002 The Ilex Press Limited

A CIP record for this book is available from the Library of Congress

This book was conceived, designed, and produced
by The Ilex Press Limited, The Barn, College Farm,
1 West End, Whittlesford, Cambridge CB2 4LX England

Sales office: The Old Candlemakers, West Street,
Lewes, East Sussex BN7 2NZ England

Publisher: Alastair Campbell
Executive Publisher: Sophie Collins
Creative Director: Peter Bridgewater
Editorial Director: Steve Luck
Art Director: Tony Seddon
Editor: Chris Middleton
Designer: Hugh Schermuly
Development Art Director: Graham Davis
Technical Art Editor: Nicholas Rowland

ISBN 1-58663-714-2

Distributed by Sterling Publishing Company, Inc.
387 Park Avenue South
New York, NY 10016

Distributed in Canada by
Sterling Publishing
Canadian Manda Group
One Atlantic Avenue, Suite 105
Toronto, Ontario, Canada M6K 3E7

For updated weblinks and further information
on digital photography visit:
www.digital-photos-click-by-click.com
This site is updated regularly.

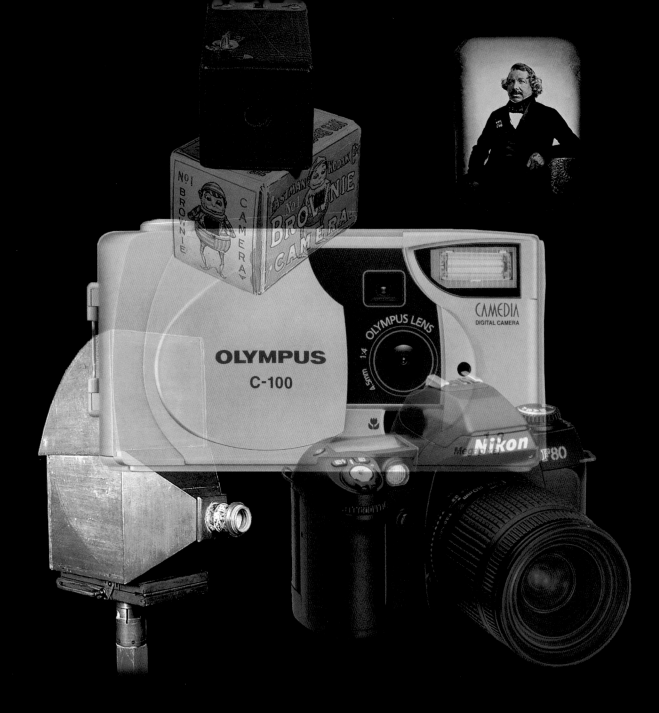

1

An Introduction to Digital...

Digital photography is the remarkable realization of a 150-year photographers' wish-list. It offers instant gratification allied with complete mastery over the results, combined with an affordable and portable technology in an easy-to-use package. And yet digital photography is, simply, photography, just like the Daguerreotypes of yesteryear and the medium-format photos of today. Whether you take a picture using light-sensitive paper in a camera fashioned from a pinhole in a shoe box, or hold in your palm the latest hi-tech digital wonder, the end result is the same: a picture that hopefully will strike an emotional note. The difference is that with digital photography you can do what once required expensive equipment and complete darkness: manipulate images however you want...

CLICKING THE LIGHT FANTASTIC!

A photograph—conventional or digital—is a fleeting moment captured for ever. In 1839, on viewing a demonstration of the process of picture-taking, the astronomer Sir John Herschel described it as "a miracle!". And that power to amaze, inspire, and excite continues to strike a chord even today.

The 19th century was a time of great invention. In Britain and America scientists, civil and marine engineers, architects, and experimenters in every field were developing technology for ever bigger buildings, bridges, ships, and locomotives, while surgeons too were making incredible advances in medicine. It was a time of upheaval and change, though with the emphasis firmly on the industrial rather than the cultural.

In the midst of these great endeavors, in 1826, French inventor Joseph Nicephore Niepce attempted to find a practical use for the recent discoveries made with light-sensitive chemicals, known as silver halide compounds. By marrying the artists' tool and the fairground novelty *camera obscura* (see panel) with a small square of pewter coated with silver halides suspended in a solution of asphalt, Niepce succeeded in taking the world's first photograph, an eight-hour exposure of a farmyard.

Photographs from Niepce's camera required extremely lengthy exposure times, during which the asphalt hardened and the image was captured, and for this reason the process was essentially useless for all but inanimate subjects. What's more, the images were

A SHOT IN THE DARK

A phenomenon known to the ancient Greeks, the *camera obscura* (from the Latin for "dark room") projects an outdoor scene by admitting light through a hole and recreating the scene on an opposite wall, or on a table. Unlike the camera as we know it, no means existed for recording the projected image, although artists once used small *camera obscuras* to copy from life by sketching over the projection as an aid to accurate reproduction.

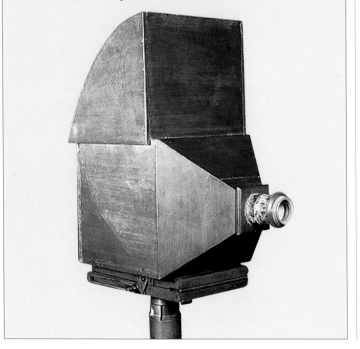

dim and fuzzy; but for all their faults they were recognizable and available for others to view—they were photographs.

After some years' experimentation, Niepce met up with fellow Parisian Louis Jacques Mande Daguerre, who hit upon the idea of "developing" the photo after it had been exposed rather than as a part of the exposure itself. Developing an image in this way shortened exposure times significantly. Daguerre also discovered that images could be fixed by immersing the developed photograph in a salt solution. In 1839 (several years after Niepce's death), Daguerre announced to the world the first practical photographic process. The pictures from this process, known as "Daguerreotypes," became extremely popular, as did the little tin photos they produced.

Daguerre's photos were "one-shot" positive pictures. That is, the captured image was developed as a positive image (the equivalent of a print in a package of photographs) without a negative step in the process. While this might at first appear to be a perfectly reasonable approach, the only way to make a second photograph of the same image was to take an identical picture again!

Early Negatives

Briton William Henry Talbot solved the problem. In 1840, Talbot announced his "Calotype" process. This added a negative stage to picture-taking (an image in which the light areas are dark and the dark areas light). Talbot's Calotype negatives could be used to make an unlimited number of positive prints on specially prepared, chemically treated paper.

One disadvantage of Talbot's paper negatives was that the imperfections in the paper produced correspondingly fuzzy images. A cousin of Niepce's, however, had the solution. Abel Niepce de Saint-Victor coated glass plates with light-sensitive chemicals embedded in the albumen of eggs. The glass negatives produced very fine pictures, but exposure times remained comparatively slow. Building on Saint-Victor's work, Frederick Scott Archer refined the chemicals in the coating and

EXPENSIVE MANIA

Daguerreomania, as it was known at the time, was only for the rich. A single Daguerreotype cost about a guinea (£1.05)—a week's wages for the average manual worker.

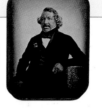

Small and fuzzy maybe, but Daguerreotypes (*above*)—the little tin pictures created using the process devised by Louis Daguerre—were the first commercially available permanent images captured from life. The Kodak "Box Brownie" (*left*) was the world's first camera for everyone. Containing enough film for 100 exposures, the camera was simply returned complete for processing. Suddenly, photography was a hobby almost everyone could pursue.

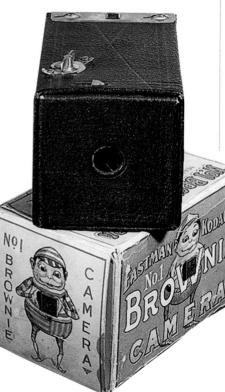

devised an improved processing method ("Collodion"), which reduced exposure times to two or three seconds and substantially reduced the cost to about a shilling (5 pence) for each print.

Pictures on a Plate

One final difficulty remained: managing glass negatives was a "wet process," that is the plates had to be coated, exposed, and processed while wet. This cumbersome process led Dr. Richard Maddox to experiment with gelatin coatings, and by 1871, Maddox had perfected a "dry-plate" process. And when, in 1884, US bank clerk George Eastman combined lengths of the recently invented celluloid with gelatin-based photographic coatings, modern film and modern photography were born.

Amazing though photography was, the invention met with hoots of derision from artists and critics, who dismissed the process as one that was largely mechanical with little creative input. It was worthless, they said, or

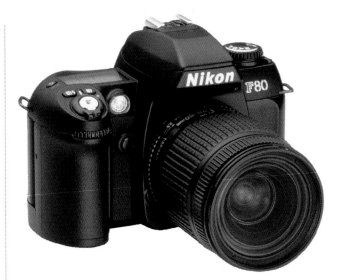

at best easily mastered. The truth, of course, just as much then as it is now, is that the mechanics of photography are indeed mastered relatively easily, but the eye of the photographer is as potent a conduit for artistic expression as any painter's brush.

While the cultural elite remained skeptical, the public took photography to their hearts. Early equipment was cumbersome and the

Single-lens reflex (SLR) cameras such as this high-quality Nikon use a folding mirror to project the image from the lens to a viewfinder. This arrangement enables the photographer to see exactly what the camera sees thereby sidestepping the possibility for parallax error.

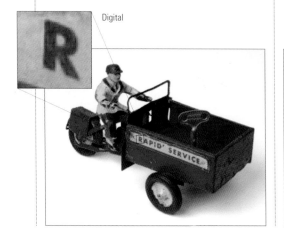

Digital

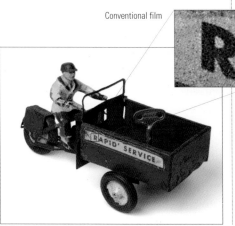

Conventional film

When shown greatly enlarged, the visible pixelation of a good-quality digital image is comparable with the grain of conventional film.

chemical processes complex and delicate, but photography could be learned by anyone who set their minds to the task.

The Pocket-sized Miracle

The same George Eastman dreamed up the notion of a camera that could be held in the hand and carried everywhere, and which used a roll of film. The camera would then be simply handed over for processing at appointed agents, such as pharmacies, and returned with the photographs and ready-loaded with fresh film. Eastman's invention underwent further refinement when Oskar Barnack, head of design and development at camera manufacturer Leitz of Wetzlar, Germany, combined 35mm cine film with a specially designed, pocket-sized camera that really could be taken anywhere.

The Digital Leap

Little more than a decade after Barnack developed the pocket-sized 35mm camera, John Von Neuman in the US and Alan Turing in Britain were busy laying the foundations of modern computer science. By the 1950s, computers were room-sized monsters, but the machines established the principles of binary computing. The arrival of transistors, solid state electronics, and, eventually silicon and miniaturization, finally paved the way for today's pocket-sized digital devices.

The first digital cameras began to appear at the end of the 1980s, along with crude image scanners and low-resolution laser printers. Resolution was abysmal, memory quotients shameful, and prices astronomical.

POWER VISION

The first electronic computers filled rooms, consumed megawatts of electricity, sported just a few dozen bits of memory and had a "brain" capacity that an intelligent food processor would put to shame. By comparison, your digital camera has a memory quotient measured in Megabytes and processing power beyond the wildest dreams of the early computer scientists, and all contained within a case you can keep in a shirt pocket!

But the companies experimenting with digital cameras continued to develop the technology and by the mid-1990s, affordable cameras became available that offered reasonable resolutions at sensible prices.

Today, you can buy a multimegapixel digital camera for less than an average week's salary. Most will provide photorealistic images in a package that will slip easily into the pocket. You can manipulate those images on a personal computer, print them, and enjoy near-professional results with remarkable ease.

Compact digital cameras like this smart little Olympus make picture-taking easy. The camera calculates the exposure, automatically focuses the lens, and captures a high-resolution image when you fire the shutter. All you have to do is point it at a suitable subject!

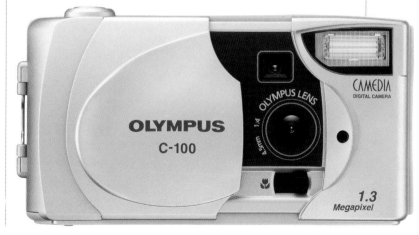

2

Hardware
Made Easy

Pixels, CCDs, firmware, digital this, digital that, resolution, and connectivity... and all you wanted to do was take a picture! The camera has, without a doubt, moved firmly into the 21st century. But understanding the technology and making use of that new-found knowledge of hardware and software to get the best from your digital camera and produce fantastic photographs seems elusive. If knowledge is power, then understanding your camera is the most powerful way to perfect its use and produce images that will not only please you, but all who see them...

BITS AND PCS

"Digital camera"—the name is at once fascinating and a little frightening. It conjures up daunting lists of associated jargon. So exactly what is "digital" and what effect does it have on picture-taking?

The word "digital" has been common currency for 30 years and is used to describe everything from watches and calculators to, more recently, radios, televisions, and cameras—but few understand what the term really means. While understanding the technology isn't a prerequisite for using a digital camera, some knowledge *will* enable you to maximize the opportunities the hardware offers. And, what's more, it isn't that complex.

The Future is On or Off

Turn to the dictionary for a definition of digital and you'll be rewarded with the stark description: "of digits;" not terribly helpful, but nevertheless that's the nub of what we're trying to understand. Digital technology relies on acquiring and manipulating picture, audio, or other information as a sequence of binary digits—the numbers 1 and 0—where 1 represents the presence of data, and zero its absence. The beauty of these 1s and 0s is that they can be represented by anything which has two states (hence binary), on and off: a switch, a light bulb, or a transistor (which is, after all simply a switch) on an integrated circuit (IC).

Let's apply the binary concept of "ons" and "offs" to musical recording. A traditional vinyl-based recording is captured within, and

CAPTIVE IMAGES AND RESOLUTION

A digital camera works much like a conventional model, in that light passes through a lens and is recorded inside. However, in place of film, the digital camera has at its heart a chip known as a CCD (charge-coupled device). This, essentially, is a matrix of tiny light-sensitive cells. The tinier and greater the number of cells, the better the resulting image—the higher its "resolution." The CCD passes varying electrical charges to a device called an analog-to-digital converter. These are transformed into 1s and 0s (binary data), and from there sent to a memory device for storage. The

CCD and its cells are similar to conventional film and its silver-halide grains, in that each captures the light that makes up the resulting picture. But unlike a conventional camera, you can't change a digital camera's CCD as you can a conventional camera's film.

recreated from, a continuous groove in the vinyl, which, when fed through a transducer (a device for converting one kind of energy into another, in this case the movement of the needle into an electrical signal), produces a continuous, varying signal—one which has peaks and troughs. There is no "on" and "off" state, except where the music itself begins and ends. This is a called an analog signal.

By contrast, a CD recording has no such grooves. Instead, the music is "sampled" (examined) by a device, usually a computer, during which it is broken into a stream of tiny chunks of ons and offs, 1s and 0s. Just how tiny is vitally important, as we'll discover later on, but suffice to say that early CD recordings did not break the data into small enough bits ("binary digits"), so the quality was, for a short time, inferior in some ways to vinyl.

The Orchestra Pits

Quality issues aside, the stream of 1s and 0s is recorded as microscopic pits "burned" onto the surface of the CD. To recreate the music, a laser scans the pits, noting where the 1s and 0s ("pit" or "no pit") fall. After a certain amount of interpreting by clever computer programing, the CD player recreates the music. Although the sound from the CD player starts out as a sequence of ons and offs, the listener hears continuous music.

Digital Pictures

Similarly, light and shade entering a camera is divided into a stream of 1s and 0s which, when manipulated by software, reproduce the original image. Enlarge the image sufficiently and you'll see that it is in fact a series of blocks ("pixels"—of which more later), but the overall image is generally of sufficient quality to fool the eye.

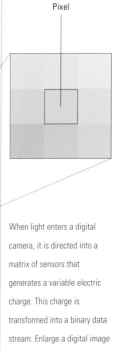

Pixel

When light enters a digital camera, it is directed into a matrix of sensors that generates a variable electric charge. This charge is transformed into a binary data stream. Enlarge a digital image and eventually you'll see the tiny blocks of picture data which fool the eye into seeing a continuous image.

BUILDING BLOCKS

Resolution, pixelation, and interpolation—although they sound complicated—are the stuff of which digital images are made. Understanding what they are will assist you in buying and using a digital camera.

On the previous pages, you were introduced to the basic concept of resolution. A simple equation describes what's required: tinier samples (and therefore more of them) equal higher-quality audio, pictures, or whatever it is that's being sampled. This is called a high sampling rate. But why should more equal better? Think of it this way. Draw a circle with a pencil around the base of a tumbler. There are two ways to find the length of the circle's circumference. The precise mathematical formula $\pi \times D$ (3.14 times the diameter) will provide the figure, or you can use a ruler and try to measure bits of the circumference. It follows that the tinier the bits of circumference you measure, the more accurate will be the final measurement. Big bits give a loose approximation, smaller bits, a closer one.

Digital Approximation

So it is with pictures, sounds, and anything else that's digitized (rendered into bits of data). Greater resolution results in a digital sample that is more convincing to the eye or ear. However, it is a paradox of the digital world that whereas accuracy to the last bit is essential for correct operation (for example, a single bit of bad data can bring even a supercomputer to its silicon knees), a digital

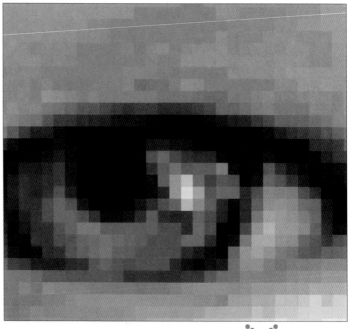

A portion of a digital image enlarged. At this magnification it's easy to see the individual pixels (picture elements) which make up the picture.

Open your image with picture-editing software and you can summon a dialog to determine exactly how many of these pixels make up your image.

ESTIMATE TO ACCUMULATE

A pixel count provides a guide to the resolution of the camera and the pictures it will produce. However, some manufacturers use a software process known as "interpolation" to increase the factor of resolution. Interpolation is a method by which more pixels appear in the picture than were actually captured by the camera. "Real" pixels are examined and the camera's software guesses what a pixel which falls between them might look like. The new pixel is added to the image and the picture's pixel count grows accordingly.

Interpolation can result in pictures which have a resolution far in excess of that captured but, as you might imagine, the results of guessing what pixels look like can never equal images based on actual pixels. Interpolation was a commonplace technique in the days of VGA cameras, but hardware has advanced at such a pace that interpolated pixel counts are now only rarely quoted as a factor of resolution for digital cameras.

Interpolation is not a con, by the way, as long as it's clear to you that an interpolated resolution is not the same as *actual* resolution. Indeed, all good image editing software cleverly interpolates pixels once you enlarge an image beyond the resolution of the original; otherwise your enlargements would be pixelated.

Although interpolation will fill in the rough gaps in a low-resolution picture, it cannot add true picture data where none exists. The results of interpolation are generally superior to the original image, but the effect remains visible.

representation of an analog occurrence from the real world is never anything better than an approximation!

Elementary Pictures

If you've shopped for a digital camera, it's certain that you've encountered the word "pixel." Even if you have no idea what a pixel is, it probably became clear to you quite quickly that more is definitely better as far as pixels go, hence the buzzwords, "megapixel" and "multimegapixel."

Pixel is another one of those contractions of words favored in the hi-tech world and which, in this case, is a contraction of the words "picture" and "element." Pixel refers to the smallest addressable element of a picture—that is, the smallest block of a picture that can be switched on or off to represent light and shade.

The earliest digital cameras provided a typical resolution of 320x240 pixels. An image at this resolution will appear crude and "blocky" when viewed onscreen or printed, because there aren't enough pixels to fool the eye into seeing a "continuous" flow of light and shade. Advances in technology soon led to cameras that were able to capture images at 640x480 pixels—matching the best in PC computer screen resolutions of the time. Images at this resolution appear smooth onscreen but still look crude when printed, unless the picture is very small, say,

Examine the pictures below and you can see why buying a camera with the highest possible resolution is preferable. The images on the left were taken with a one megapixel camera (the close-up shows how the image decays under close scrutiny), while with the images on the right—taken with a four megapixel camera—even the close up shows remarkably good resolution.

2 × 1.3 inches. Any bigger, and each pixel must be enlarged to the point at which it becomes clearly visible and the image is said to appear "pixelated."

By the late 1990s, the first megapixel cameras became available. These offered a height by width resolution that adds up to more than a million pixels. The introduction of megapixel cameras moved digital photography into the fast lane because images could at last be reproduced at the standard enprint (150×100mm) size, and yet be "photorealistic" (supposedly indistinguishable from a real photograph).

If you're choosing a digital camera, and unless you're on a very tight budget or will

ALL-SEEING EYE?

Today's "hobbyist" multimegapixel cameras offer resolutions of between 2 and 3.5 megapixels. The latest professional digital cameras can provide a staggering 16 million pixels per image. But the human eye has the equivalent of 230 million pixels—digital cameras have some way to go yet!

only view your images onscreen, choose a camera with at least one megapixel capacity. These will swiftly become standard on even cheap cameras. Today, even mid-range cameras offer multimegapixel resolution—between 2 and 3.5 million pixels—which is more than enough for quality prints and enlargements.

FILES AND FORMATS

As digital image capture and manipulation have evolved, so too have increasing numbers of formats in which to represent and store the results become available. Each has its merits but all is not equal in the backing storage stakes.

Users of conventional cameras "store" their pictures as negatives or transparencies. For digital camera users too, storing an image is a distinct step in the process of creating a picture—the image is captured and stored within the camera, possibly transferred to a computer as a picture file before being edited and printed. But the intermediate stage—storing the image as a file—is an important step, and a number of formats have been devised to store digital information as efficiently as possible.

It's this drive for efficiency and accuracy, however, which has caused so many file formats to be devised. Raw picture data takes up a relatively large space within your camera and so a certain amount of compression—squeezing of the image data—is applied in order to pack more pictures into the ever-limited "backing storage" in the camera.

The Compression Problem

But compression isn't a cure-all, and many compression techniques result in degraded image quality. Some formats are rather less able than others, and which one you choose depends on your application—whether your pictures are intended to be viewed as prints or only in webpages, for example. Generally, file formats target one of two areas: color accuracy at the expense of file size, or vice versa.

BIT PART PLAYERS

Colour depth is often expressed as a binary factor: 8-bit, 24-bit and so on. Bit is a contraction of the words 'binary digit', and a bit represents one of two states (hence 'binary'), on or off. It follows that 8-bit colour (that is, 2^8 or 2x2x2x2x2x2x2x2) has a maximum depth of 256 colours. 16-bit has a colour depth of 64,000 colours, and 24-bit, 16.7 million.

There are many file formats for storing digital images and each is geared to a particular application. GIFs, for example, are generally used for relatively low-resolution images intended for the Web whereas the TIFF format is ideal for storing photorealistic pictures with high color definition.

GIF

TIFF

Files and Formats

The Formats

JPEG: (pronounced "jay-peg") The most popular format for images taken with digital cameras today is the JPEG, and there's a good reason for this. JPEG is an acronym that stands for the (International Standards Organization's) Joint Photographic Expert Group, which created the format and devised it specifically for digital photographs. JPEG files offer 24-bit color representation—that is, they can contain up to 16.7 million colors, which is more than enough for photorealistic pictures. Compression is high too resulting in small picture files (though size is relative in file formats) and the supreme advantage of the JPEG is that it only stores data for pixels that have color—white pixels require no data.

The downside is that JPEGs use "lossy" compression. Redundant picture information is actually discarded to reduce the file size. Obviously, throwing away information from the picture will degrade it. What's more, compression is applied every time the JPEG is opened and saved (though not when opened, viewed, and closed without saving).

GIF: The other major picture file format and certainly the most widespread on the Web is the GIF (Graphics Interchange Format). GIFs are ideal for "portable" pictures that are likely to be viewed only on a computer screen (for example, those you want to post on a website). Compression is very high and generally, the same picture rendered as a GIF will be far smaller than in any other format but at the expense of color—GIF only allows a maximum of 250 colors.

Compression techniques enable you to store high-resolution images with a small cost in backing storage but use with care—many compression systems are "lossy" which means picture data is discarded in favor of file size.

JPEG, maximum quality JPEG, maximum compression

TIFF: In professional publishing, the TIFF reigns supreme. TIFF (Tagged Image File Format) offers 16.7 million colors and uses a "lossless" compression equation, which retains picture data, but results in files that are larger than some other compressed picture formats.

PNG: Newcomer PNG (Portable Network Group) is a Web-oriented format designed to retain picture integrity and produce small files. Lossless compression, 24-bit color and meta-tags (indexing text for Web search engines contained within the picture) make the format ideal for Internet use.

Save Options dialog box:
- Encoding: Standard encoding / Progressive encoding
- Compression: Compression factor: 15 — Lowest compression, best quality ... Highest compression, lowest quality
- OK Cancel Help Run Optimizer...

FEATURE PACKED

All digital cameras come bristling with features, some of which you'll use every time you take a picture. Resolution is paramount, but LCD screens, self timers, and on-board special effects can make picture-taking more fun and ease you gently into the world of digital editing.

Between the writing and the reading of this book, prices for digital cameras will have fallen considerably and specifications increased significantly.

Until relatively recently, 640x480 pixels was considered a reasonable working resolution, and then along came affordable multimegapixel cameras, and now 640x480-pixel cameras are considered acceptable only for pictures intended for the Web. So if your idea of digital photography is as a replacement for a conventional camera and your pictures will be printed, a multimegapixel camera is a must.

Specifications

All digital cameras have a lens (fixed and plastic, in the case of cheaper offerings), viewfinder (low- and mid-range cameras are "compacts," and the viewfinder is separate from the lens), and a body which houses the electronics and perhaps a removable storage option. Digital compact cameras are usually equipped with a lens that is the focal length equivalent of the 35mm to 50mm lens of a conventional 35mm film-based camera, and provide a field of view broadly comparable to the human eye's.

The very cheapest cameras have a fixed-focus lens (don't confuse this with auto-focus)

which, combined with aperture and shutter speed, will focus everything from about 1.5 meters to infinity. Most digital cameras offer auto-focus and a macro facility for close-up pictures. Many better-quality cameras sport a zoom lens that novice photographers generally think of as a tool for getting closer to

This Nikon digital camera is capable of taking high-quality digital images. It is a 5 megapixel camera, and features a 35–280mm motorized zoom lens.

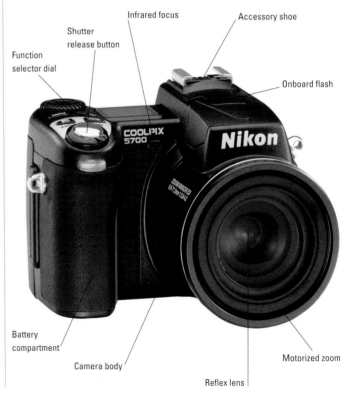

Infrared focus

Accessory shoe

Shutter release button

Function selector dial

Onboard flash

Onboard flash

COOLPIX 5700

Nikon

Battery compartment

Camera body

Reflex lens

Motorized zoom

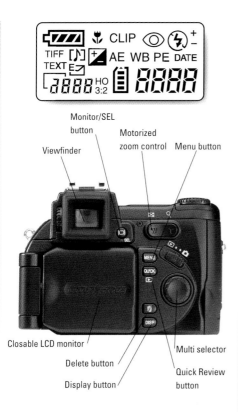

Viewfinder

Monitor/SEL button

Motorized zoom control

Menu button

Closable LCD monitor

Delete button

Display button

Multi selector

Quick Review button

distant action. However, the zoom lens is more useful as a framing device, letting the photographer remain outside the "personal space" of the subject.

All digital cameras can download pictures to a computer. Early examples were equipped with a serial connector. Although slow, a serial connector is available on virtually every PC (and many Apple Macs, in a slightly different guise) on the planet. USB (Universal Serial Bus) is a modern variation on the serial theme. It's faster, hot-swappable (the computer recognizes your camera as soon as it's connected and launches the appropriate software, there's no need to reboot), and standard on new PCs and Macs. More recently, Apple's FireWire has become available. FireWire is another variation on the serial theme, but exponentially faster than USB. FireWire ports are built into more recent Macintoshs (such as the iMac) and PCs.

Digital Slideshow

Connectivity doesn't stop at linking your camera to a computer. Some cameras offer a "video out" function, which enables you to connect the camera to a television set or VCR and view your pictures as a slideshow.

But the most obvious feature that sets the digital camera apart from its conventional cousin is an LCD screen for reviewing, editing, and deleting pictures, configuring the camera and selecting options. All but the cheapest cameras have an LCD, which can also double as a viewfinder. The LCD generally gives access to other features too, such as setting resolution, compression, and file type, and the result of applying an onboard effect, say, sepia toning, can also be viewed on the LCD screen.

The back of the same camera showing its various control features, and above it, a typical control panel. These indicate battery life, file format, exposure, macro, red-eye, and flash settings, among other things.

CONSUMER CHOICE

Digital camera manufacturers fall into two camps: those from traditional camera companies such as Nikon, Canon, and Olympus, and those from companies that are principally involved in the manufacture of consumer electronic goods, and which make everything from computers to microwave ovens (Sanyo, Samsung, Hewlett-Packard, and Casio). The traditional camera manufacturers tend to produce digital examples that are familiar in size, shape, and operation to anyone who has used a conventional camera, whereas the latter group often approach digital camera manufacture in more novel and interesting ways. Take each on merit and make your choice on features and price.

DIGITAL STORAGE

So you thought you'd seen the last of film? Think again! Just as conventional cameras require conventional film, digital cameras need digital "film," but the advantage is that it can be used time and time again.

Digital pictures are big! A high-resolution photograph might require as much as 5 or 6 Megabytes (Mb) of storage within the camera. The first digital cameras had fixed internal storage that was gradually filled as pictures were taken. When the camera was "full," the pictures had to be transferred to a computer or erased. Today's multimegapixel cameras produce images at stupendous resolutions, and with truly enormous file sizes as a result. Not for them the fixed internal storage scheme. Instead, storage cards—"digital film"—are used. Typically, manufacturers have thrown their weight behind competing formats. The popular cards are for the most part standard memory cards, such as might be found in an electronic organizer. Making use of removable cards enables photographers to keep spares in their camera case and plug in a fresh one when necessary. Of course, there's nothing remotely like conventional film within the case of the card. It is simply an electronic device which features memory chips and a means by which information can be stored and retrieved.

The End of Floppies

For a time, Sony persevered with cameras that used floppy disks as their storage medium. The cameras were slightly cumbersome, but the floppy disks made a lot of sense. They're cheap, widely available, portable, and reliable. However, the advent of megapixel cameras and large picture files spelled the end for the floppy. What's more, economies of scale equate to ever-cheaper storage cards as digital cameras become more widespread.

At present, two major contenders vie for your camera's card slot: CompactFlash and SmartMedia. Despite the name, CompactFlash cards are physically larger than SmartMedia

Memory cards are available in generic formats such as the CompactFlash card (*right, above*) or proprietary as with this IBM Microdrive (*right, below*).

SmartMedia cards (*right*) are cheap, readily available, and tiny, which means you can carry spares for those outings where you intend to take a lot of pictures.

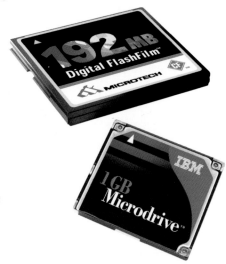

CAPACITY				
SIZE OF CARD	**NUMBER OF IMAGES**			
	Typical JPEG basic	Typical JPEG normal	Typical JPEG best	Typical 3-megapixel TIFF uncompressed
8Mb	26	11	6	1
16Mb	53	22	12	2
32Mb	106	45	24	4
64Mb	213	91	49	8
128Mb	426	182	98	16

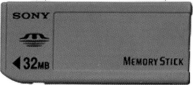

ones, and they offer greater storage space. You can buy SmartMedia cards ranging from 8Mb to 64Mb, but CompactFlash is available up to 128Mb. If you plan to take a lot of high-resolution images for printing, CompactFlash is probably the best choice, but don't be put off a camera simply because it uses SmartMedia. A 64Mb SmartMedia card will store a lot of

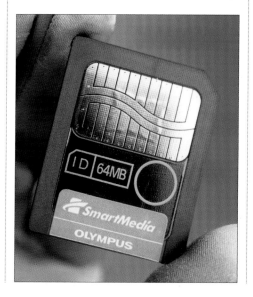

pictures, SmartMedia cards are cheaper, and unless you're trying to capture pictures of unrepeatable events, the seconds it takes to swap a card are not really a problem.

SmartMedia cards can be plugged into special adapters and then inserted in a computer and accessed in the usual way. This negates the need for cables and software links to a computer to transfer pictures.

Sticks

Sony offers a proprietary card called a "Memory Stick," which can be used with other Sony equipment, and there are also PCMCIA memory cards that are occasionally used in cameras. Credit card-sized PCMCIA cards originated in the computer world, where they're used to house everything from modems and network adapters to hard disks within their cases. Cameras use standard Type II PCMCIA memory cards (there are three "types" of PCMCIA, each with slightly different dimensions and varying power requirements).

Sony's Memory Stick is a proprietary format that is relatively expensive when compared with CompactFlash and SmartMedia. It can, however, be used in other Sony products, which might mean a saving if you're already a user or a fan!

MAKE THE CONNECTION

Taking a picture is just the first step—you must get the image into your computer and printer before it becomes the print that your friends and relatives would recognize as a photograph.

All digital cameras are equipped with a means by which they can be connected to a computer, so that you can transfer ("download") your pictures for storage, manipulation, printing, emailing, and so on. The legacy option, certainly the slowest, and arguably the least reliable, is the RS232 serial connection. Serial transfers are very slow compared with, say, USB and, despite being around for many years, RS232 has a strong potential for problems.

Going, going...

Problems arise because there are so many ways to configure an RS232 connection and setting one up can be a minefield for even the most technically aware. As well as configuring the connection, it must be established manually too. Unlike USB, the computer doesn't know when you've connected your camera. You must link the camera and the computer, launch the necessary software, and instruct it to begin the transfer. In short, serial connections are yesterday's technology.

Why then, does RS232 continue to be used? Principally, because all PCs have a serial port of some description, and the majority of Apple Macs have one too. And until relatively recently, nothing else had come along to take the technology's place.

Older cameras and very cheap examples offer serial transfers. However, some mid-range cameras, alongside a USB port, also provide RS232 as a legacy option; this can be useful if you're away from your desktop machine and only have access to an older laptop or palmtop for example.

Universally Superior

In the mid-1990s, some of the major players in the computer world got together to establish a new "standard" for serial connections. Compaq, DEC, IBM, Intel, Microsoft, and others created the Universal Serial Bus (USB), which is to RS232 what a Ferrari is to a Model T Ford. USB is "hot-swappable,"

When you connect your camera to your computer, the screen will tell you that you have "created" another drive (i.e., your camera) and will list the files (your pictures) on that drive.

WHAT'S IN A NAME?

In computer speak, a data connector on a computer is known as a "port."

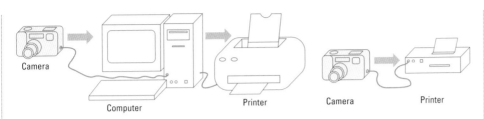

Camera
Computer
Printer
Camera
Printer

which means that when you attach a camera, the computer knows it's connected, automatically invokes the necessary software and establishes a (usually) reliable link. You don't have to switch off, reboot, or manually launch software.

The speed of transfer is orders of magnitude beyond legacy serial connections, and furthermore there's no need to mess around with the technicalities of a serial connection. Almost all new PCs over the past couple of years (and certainly all brand new ones) have one or more USB ports, as do Apple Macs, and USB is standard across platforms—the same cables work with any machine that has USB ports. The connectors themselves are small and easy to use.

Fly by Wire

Not for nothing is Apple a leader in the professional media world. In 1995 the company launched a new serial transfer scheme known as "FireWire." Capable of truly blistering transfer speeds (400 megabits per second (Mbps), compared with USB's 12Mbps), FireWire languished for a time as a poor second to USB because no suitable application existed. Then Sony included a FireWire port on its newly launched digital video camera, and suddenly the potential for FireWire became clear. Where digital photo-

graphs produce large files, digital video generates memory-defying files of breathtaking proportions. Transferring them required the incredible muscle of FireWire. All G4 Apple Macintosh computers have these ports, and so do many new PCs. FireWire is generally reserved for high-end multimegapixel professional digital cameras, which generate large file sizes.

Computers use two types of data transfer connection: serial and parallel. Serial data transfer involves sending each piece of data one after the other along a single connection between communicating devices. A parallel connection is one in which multiple bits of data are sent at the same time along several connections, and each piece of data has its own line.

Although it's entirely possible to use and enjoy a digital camera without going anywhere near a computer, you'll be able to get far more from your images by transferring them to a Mac or PC. A computer makes an excellent storage medium for all that image data too.

Computers provide connectors ("ports") and various software protocols to enable users to transfer data. Slow connections such as bi-directional parallel and serial ports are gradually fading in favor of faster technology, such as USB and FireWire, which are variations on the parallel and serial theme.

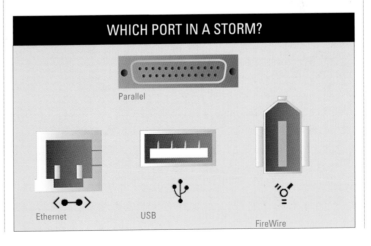

WHICH PORT IN A STORM?

Parallel

Ethernet
USB
FireWire

WHICH COMPUTER?

Though it isn't absolutely necessary, chances are you'll want to connect your camera to a computer to store, edit, and print your pictures. Two distinct types of computer dominate the marketplace, and which you choose depends on a number of factors.

"No-one ever got fired for buying IBM," ran the advertising slogan, and in the early 1980s it was true. IBM's personal desktop computer (as opposed to the mini and mainframe computers that IBM also manufactured back then) quickly came to dominate the market; and in the PC's wake followed an avalanche of clones. Indeed, so successful were these lookalike computers that sales of them eventually exceeded those of IBM, and PC-compatible manufacturers such as Compaq ousted IBM as the number-one sellers.

PC Versus Mac

When it was launched, the PC came with a command-line driven operating system (that is, you typed in obscure commands such as DIR, DEL, MD, and so on) created by a little-known Seattle software company called Microsoft. Then Apple launched its Macintosh computer, which featured the world's first truly commercial point-and-click graphical interface. "Windows," icons, a mouse, and pointers passed into common currency, and Microsoft wanted its share. The Seattle company launched Windows, which was treated as something of a joke for several years in its earlier guises. However, with the launch of Windows 95,

Microsoft hit paydirt and computer users around the globe bought and installed the system, while Apple failed to license its own products to other developers (its key error).

So successful is Microsoft's system that today a PC and a Windows computer are generally thought of as one and the same thing. However, publishing professionals use the Apple computer almost exclusively, and with the launch of the PowerPC and then the iMac, Apple began to claw back respectable

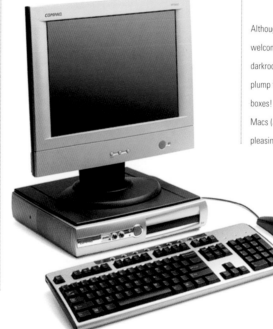

Although a computer is a welcome friend in the digital darkroom, there's no need to plump for large and ugly boxes! Today's PCs (*left*) and Macs (*above*) are esthetically pleasing in their own right.

market share. Which one you choose—PC or Mac—depends on who you are and what you want to do. If digital photography is a pastime, and your pictures will be stored on a computer that is also shared with your family, it's almost certain that you'll choose (or probably already own) a PC.

A Very PC Solution

PCs are generally cheaper than Macs and more widely available. All PCs use off-the-shelf plug-in components that are easily swapped when repairs are required, there's a wealth of quality software of all kinds to support the machine, and finding help is as easy as asking a friend or work colleague—every second person is familiar with PCs and Windows.

The Mac, on the other hand, remains relatively unknown outside pro-media circles, although the iMac has changed that to an extent. But that doesn't mean Macs aren't an excellent choice for digital photographers. Macs offer excellent graphic options as standard across the platform (no grappling with video driver software from third-party graphic card suppliers), a robust operating system, which is arguably better integrated, smoother, and more intuitive than Windows, and some very high-quality, image-manipulation software, some of which can be found nowhere else.

All new Macs and PCs feature plenty of RAM, large hard drives and fast processors; each offers USB ports as standard (and sometimes FireWire), and each provides access to CD-writers, Zip drives, easy Internet access, and a lot more to broaden your horizon.

SOFT OPTIONS

Though a comparatively large investment, a computer is simply the means to an end: using image-editing software. This software is a primary reason why digital photography is so much fun. Once the pictures in your camera are transferred to your computer, image-editing software enables you to view and manipulate them in ways that previously required an entire darkroom's worth of expensive equipment and years of experience. Image editors are available in many guises, some aimed at beginners, some at media professionals. Prices vary enormously too, from free (that is bundled with the camera) to hundreds of dollars. However, software is one of the few products about which "you get what you pay for" can't be said. A relatively cheap image editor such as Jasc Paint Shop Pro for the PC is packed with features, it's easy to use, and you can download a try-then-buy version from the Internet before actually spending your money. At the other end of the scale, Adobe Photoshop has every feature imaginable and is available for both PC and Mac—but at a hefty professional price!

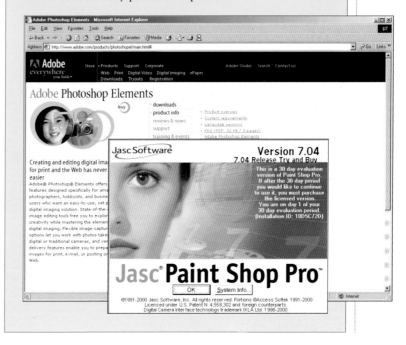

SILICON-FREE PHOTOGRAPHY

Digital photography means "instant" pictures and no more processing costs. You've side-stepped film, but have you had to acquire a computer instead? And what are the options if you don't own a computer?

Don't let the lack of a computer put you off buying and using a digital camera. Computers have certainly entered millions of homes over the past 10 years or so, but not everyone owns one. Just because you're a digital photographer doesn't mean you want to be a computer programer too!

Computer or Printer?

Of course, the first thing to realize is that manipulating digital images calls for as much or as little technical expertise as you're willing to acquire. With no more knowledge of computers than switching them on and plugging in cables, you can download your pictures and save them to disk. A chapter or two of this book, and half a day invested in experimenting, and you'll be cropping, re-sizing, and toning your pictures, burning CD picture albums, and sending images to friends over the Internet like an old hand; and after that, the digital darkroom is yours to command.

But let's assume for a moment that you don't have a computer, and prefer instead to invest in the best camera your money can buy. Back to that "household penetration" quotient.

You might not have a computer, but it's certain that a relative or a friend has one, and while they probably won't want you spending hours poring over their machines with your pictures, an hour here and there while you download them and file them to a CD ought to be okay.

Orphans who shun friendship aren't altogether stymied either. Those who work usually come into contact with computers, those who don't can probably gain access to silicon at a public library, and students of all ages can petition their schools and colleges for

If you don't have space for a full-sized desktop computer consider a laptop. These have the processing power of many desktop machines in a compact and convenient format. Be aware though, that you'll pay more for equivalent features to a PC.

time on a machine (but always remember to ask permission before you make free with someone's computer).

In the Hand

If not owning a computer is an issue of space, consider a palmtop or laptop. These hand-held and portable computers offer processor speeds, hard-drive space, and RAM memory that's on a par with the desktop computers, but they occupy far less space. All will enable you to connect to the Internet too, so you can post your pictures (that is, insert them into a webpage) or send them to others via email. Despite their convenience and incredible miniature tech-nology, palmtops and laptops are not that much more expensive than a comparable desktop computer, and have many advan-tages. There are also good deals to be had on second-user and end-of-line machines.

Your Prints Will Come

Those who truly don't want a computer of any sort don't have to have one. Many inkjet printers sport a built-in card slot as standard. Fill your camera with pictures, withdraw the storage card, plug it into the printer's slot, select from a range of printing options on the printer's LCD menu panel (enlargements and reductions, color or mono output, and so on), and go ahead and print. You'll get good results, and all without a computer. And many cameras offer basic editing features right in the camera so you can even crop and compose your pictures before printing them.

Shop Smart

Some conventional photography outlets and pharmacies also provide a print-from-card option. Take your pictures as before, eject the card, and pop it along to the store much as you would a conventional film. The result is a package of prints and an empty card ready to use again.

With no computer or printer (*above*), you can take your digital camera storage card to a main street processing outlet (almost all conventional camera and film outlets offer this service), or email your image files to an online processor (*below*). It's easy!

Point and Click

The world of photography is littered with casualties! There are no bandages or medicines and the only bruising is an ego or two, but they are casualties nonetheless, as the small ads of photography magazines fill up with hi-tech camera equipment, sold off cheaply as people's interest wanes. Why does it happen? Because the wise photographer realizes that a top-of-the-range digital camera produces box-brownie pictures in the "wrong" hands. And what are the wrong hands? Those that skip this chapter; it contains old—it's true!—but exceedingly valuable advice for budding picture-takers. Covered here is composition, lighting, positioning, and the half dozen or so other techniques which, while simple in themselves, turn good photographs into great ones.

GROUNDWORK

The basic rules of photography exist to guide and hone your talent, not to stifle it.
Learning and mastering these simple techniques will equip you with all that's required
for truly gorgeous pictures—the rest is up to you.

Guitar players spend much of their time worrying about whether learning to read music will spoil their musical intuition—that indefinable "something" that ensures their playing is inspired. It's a worry that could apply equally to photographers. After all, many of the world's most famous images were taken on the hoof with little regard for the rules of composition and lighting, or else these rules are abandoned on purpose to create a particular effect.

But what conclusion have seasoned guitarists and photographers reached? That to throw away the rule book, you have to have one first! It's a cliché but it's true, the best camera in the world won't make you Diane Arbus or David Bailey, but the cheapest disposable compact would enable either photographer to produce marvelous pictures. Photography is about looking and seeing, and good photography is about composition, balance, lighting, and tone.

Composing

Arguably, the principal factor that sets an interesting picture apart from a dull one is composition—not the subject itself, but the way in which you choose to present it.

Whether as a journalistic record of an event or an artistic representation of what you see, the appeal of any photograph can be strengthened by training your eye to see a composed picture. When you survey a scene your eyes take in everything and your brain picks out what it perceives as the important details. The camera, however, isolates just one part of the scene, framing and flattening it into a two-dimensional representation that can be dramatically different from the way you perceived it.

The "rule" might be expressed as: don't aim, frame. Build a picture rather than simply point

A common mistake is to position the strongest point of interest at the center of the picture. Add greater impact by composing your picture using the "rule of thirds," an age-old technique designed to build in balance and add drama.

The seasons have a great impact on light quality and availability. In the winter months, stark reflected light from snow will tend to fool your camera's metering system, and the result could be a poor exposure.

the camera. Assess the scene and decide where its interesting highlights lie. Allow your eye time to scan the subject in the viewfinder. If you're unsure, use the LCD screen to supplement the framing. Practice observing what's around you as potential pictures, isolating and framing portions to make subjects. Of course, the advantage of a digital camera is that you can take a picture many times while you practice this technique without wasting film.

Lighting Effects

Second only to composition is lighting. Stark lighting (such as strong flash) can have a very dramatic effect, especially in portraiture, by stripping a subject of personal space, while sympathetic soft or natural light enhances and is kind to subjects. Low-key lighting suggests reflective moods, while high-key lighting, and lighting filters and effects, can produce a party atmosphere. Although your eye might not notice it, the time of day, seasons, and weather all have a significant effect on light. Try setting your camera on a tripod and taking the same exposure at two-hourly intervals throughout the day—the difference in light is dramatic.

Balance is important to composition. Ensure the horizon is level and alter your vantage point so you can build surrounding features such as trees into the picture to support the composition.

GET A GRIP

Holding your camera, tilting and twisting it, getting up high, or crouching low—all have significant impact on your pictures, and form the basic techniques for creating more dramatic photographs.

It's likely that your digital camera is what's known as a "compact." Unlike a single-lens reflex (SLR), which uses the same lens to view and take the picture, the compact's lens and finder are separate—you look through one and capture the scene with the other. The system works perfectly well (indeed some of the world's most famous photographs were taken using rangefinder cameras—a variation on the compact theme), but there is potential for problems. The most obvious is that you leave on the lens cap or otherwise obscure its view with a finger without realizing.

Learning to handle and hold your camera will help you to avoid these simple problems. Of course, with a digital camera, obscuring your picture with a finger or the lens cap costs only time and effort while you erase the picture

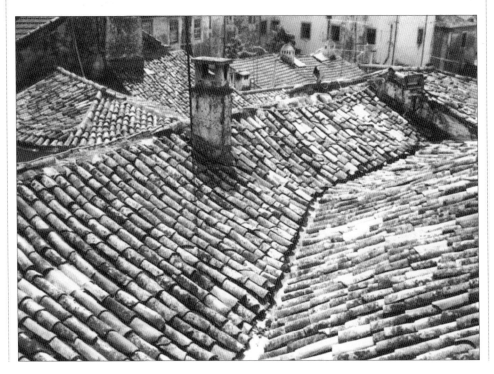

Interesting vantage points breathe life into your photographs. Look for shapes and textures to catch the eye and engage the interest of all who see your pictures. Here, the gutter between these glorious roof tiles leads the eye into the picture.

and make another exposure—there's no film to waste, and you're aware of the problem immediately. But where you are in relation to your subject matter is what will make a good picture into a great one!

Handheld

Hold your camera with a firm but gentle grip. The shutter release will almost certainly be positioned on the right- of the camera, so whether you're right or left-handed, cup the camera snugly in the palm of your left hand and curl the fingers of your right hand around its right- hand edge so that your index finger falls naturally over the shutter button—the classic landscape position. Keep your elbows tucked in and your feet slightly apart. Simply turn the camera through 90 degrees for a portrait format. Held like this, the camera will be largely immune from shake (and blurred pictures) and your fingers are out of the way.

Getting above your subject adds perspective, depth, and drama, and will enable you to frame more effectively—especially with a group portrait such as a wedding picture or a sporting event—and crop out unwanted detail. Effort made at this stage of the picture will reduce the work required during the editing process.

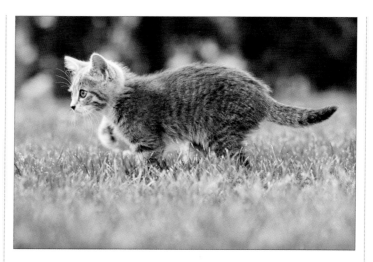

The Lowdown

Children are smaller than adults, and so are family pets, yet so many pictures of kids and animals are taken looking down at them. Better by far to get down low where you can see the world the way they see it.

Up Close

Enlarging digital images is easy, but it has a cost in resolution. How many times have you seen or taken pictures which lacked impact because the point of interest in the picture was a little blob in one corner? Getting in close to your subject will tease out the interesting aspects, and produce appealing pictures.

Never work with children and animals… unless you can get down to their eye view. Seeing what this kitten sees conjures its world rather than yours in what might otherwise be an ordinary picture.

VITAL STATISTICS

Aperture, shutter speed, and focal length are a camera's vital ingredients, and each combines to produce your picture. The same is true of digital cameras though the way these are expressed can be different.

An exposure is the result of two factors: the speed at which the camera's shutter opens and closes; and the width of the aperture through which light passes. The same is true whether you're using a conventional or digital camera. Shutter speeds are usually measured in fractions of a second: 1/30th, 1/60th, 1/125th, 1/250th, 1/500th. Aperture is measured in f-stops: f/2, f/4, f/5.6, f/8, f/16. Each stop admits half the light of the previous setting.

A slow shutter speed allows more time for the light that is passing through the aperture to reach the CCD. Similarly, a wider aperture allows more light to pass through. It follows that combinations of the two enable the same amount of light to reach the CCD.

With many mid- to high-end digital cameras, the photographer has complete control over the way these two factors are combined to produce a picture, and all but the most basic digital cameras offer some degree of control. The question is, why and when to favor aperture over shutter, or shutter over aperture? The answer lies in depth of field and

The result of incorrectly combining aperture and shutter speed is an under- or overexposed picture. It's possible to compensate for poor exposures using image editing software, but, inevitably, detail will be lost (crucial when working with a finite quantity of pixels).

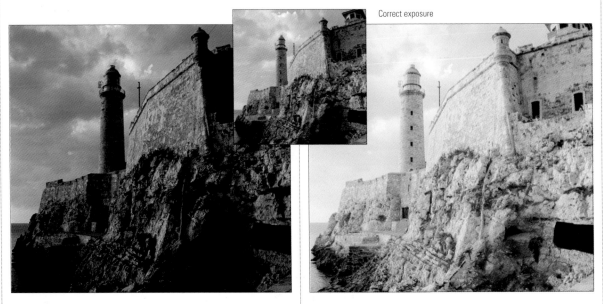

Correct exposure

Underexposed

Overexposed

movement. A narrow aperture allows more of the picture to be in focus. That is, a picture exposed at say 1/60th of a second and f16 will focus everything between a yard and infinity (described as "depth of field"), ideal for landscapes. But 1/60th is slow, and if there's movement in the scene, it could be blurred.

Light, Camera... Action!

So when taking an "action" photo a fast shutter speed of say, 1/500th of a second, and a correspondingly wider aperture of perhaps f/2.8 are used. This lets enough light enter the camera for your subject to be in focus, while other details will be blurred.

What does all this mean to digital cameras, which have a CCD rather than a shutter? Much

Looking out over vegetation, a narrow aperture and slow shutter speed keeps everything in focus, and is an ideal combination when photographing a landscape.

MISSING LINK

Electronic metering may be thought of as the missing link between conventional and digital cameras. In the 1970s, manufacturers extended the idea of a built-in exposure meter by linking it directly to electronics controlling the camera's aperture and shutter. The camera measured the light, and set either the shutter or aperture to suit the manual setting of the other. These are known as "aperture-priority" and "shutter-priority" cameras, because the photographer chooses one to suit the scene and the camera selects the other.

the same. A digital camera fired at 1/500th of a second makes an exposure just like a conventional camera. The difference is that the CCD is turned on and off for 1/500th of a second rather than the plates of a shutter passing across a film frame. The control you have over the aperture settings of digital cameras depends on the camera. Mid-range cameras allow manual aperture settings, but most have a "motion" setting for taking action photographs.

A wide aperture allows effects such as "panning." The camera is focused before the subject appears and the camera is moved as it sweeps through the scene while the shutter is released. The out-of-focus background gives a dramatic indication of speed.

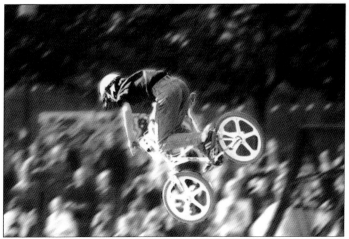

CLEAR AND CLOSE UP

A blurred image can provide dramatic impact, but more usually, your aim will be to capture scenes in perfect focus—especially important when working within the finite resolution of a digital camera.

On the previous pages you learned that focusing is as much a factor of aperture as it is of dialing in the correct distance between the lens and its subject. When light passes through a narrow aperture, it undergoes a kind of "natural" focusing. This property enables camera manufacturers to build cameras that are described as being fixed-focus—there is no way to change the focusing distance of the lens. Instead, a relatively slow shutter speed is combined with a narrow aperture to ensure that on sunny days or when using flash, everything between about 4 feet and infinity will be more or less in focus. Fixed-focus cameras are cheap and work, but they're creatively limiting.

Ghostly Images

Manual focus cameras—generally either rangefinders and SLR types—rely on the photographer to set the lens to the correct distance between camera and subject. This is achieved with the aid of a focusing tool rather than by measuring or guessing. Rangefinder cameras resemble compacts in that they have a separate lens and viewfinder, but these two lenses are linked in such a way that turning the distance ring on the lens causes a "ghost" image in the viewfinder to move. When the ghost image and main viewfinder image are aligned—the one transposed over the top of the other—the lens is focused.

SLRs generally offer a combination of aids such as a split screen and a fresnel screen. The split screen shows a divided image which is aligned as the lens is focused. When the divided image joins up, the lens is in focus. A fresnel screen resembles a pixelated digital image which is made to grow gradually less pixelated as the lens is brought into focus. The fresnel screen is used widely with twin-lens reflex cameras.

During the 1980s, auto-focusing became widely available. As you squeeze the shutter button, the camera fires an infrared (or occasionally a sonic) beam at the subject which is reflected back to the camera. The distance is calculated from the delay between sending and receiving and the shutter focused accordingly. All mid-range digital cameras feature autofocus as standard. Professional cameras

Autofocus cameras fire an infrared beam at the subject, which is then reflected back to the camera, letting its onboard sensors judge the distance and pull the lens into focus accordingly.

often feature a manual override to enable experienced photographers to choose.

Though autofocus works well, there is a small delay between pressing the shutter, focusing the camera, and the shutter firing. This can be a problem if you're trying to capture a moving target but there is a way around it known as "locking" the focus. Aim the camera at something which is at a similar distance, squeeze the shutter to focus the camera and hold the shutter button. You can now recompose the picture and fire the shutter at the required time. You can also use this method to focus on subjects outside the center of the frame but pointing the camera momentarily while you focus, then back again to take the picture.

UP CLOSE AND PERSONAL

Zooming is one of those gimmicks that camera and lens manufacturers make much of because they know that getting close to the action holds an immeasurable appeal for novice photographers (digital video cameras which offer 800x zoom lenses). However, unlike some gimmicks, zooming offers many possibilities. Certainly you can "get closer" to distant subjects, but the real value lies in the way a zoomed lens tends to flatten depth of field, tightly packing the "layers" (see composing) of a scene. This flattening effect is perfect for portraiture because it flatters the subject, and enables the photographer to get in close without making the model uncomfortable. Perhaps most importantly, zooming helps you to fill the frame with the subject, lending greater impact, and helping to avoid the classic mistake of cluttered pictures with what should be the point of interest lost in a corner.

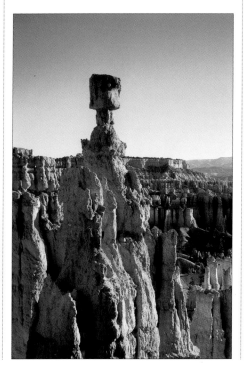

Used even on a landscape picture, zooming in on a detail—such as this almost human-looking rock formation— flattens the background and flatters the subject to create a striking image.

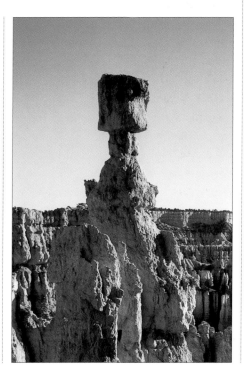

DIGITAL COLOR

During its early years photography was a monochrome process and color was the Holy Grail. But the advent of color processing brought with it the realization that black-and-white photographs can be every bit as striking.

Color stirs the emotions in a way that transcends the relative simplicity of composition and technical application. Color can convey tension, it can comfort, it can inform, or it can be simply abstract, the artistic value of the picture derived from the combination of colors within and the subject itself without recognizable form. Paradoxically, where color can convey emotion, a lack of color can have an equally potent effect. Used carefully, a grayscale treatment will bring great beauty and impact to an image.

Color Variations

It's important to realize at the outset that in photography, there is no true color. The same scene shot at the same time with the same camera but on different film, will result in photographs that are very different tonally. Digital cameras vary even more so. Manufacturers tend to weight one color over another and by its very nature the digital process itself is incapable of anything more than an approximation (albeit a pretty good one!) of the range of colors in a scene. Though 24-bit color offers a remarkable palette of more than 16 million hues the human eye can distinguish almost infinitely subtle variations which can be

This scene is brought to life by the availability of color which gives reason to the composition and delights the eye.

lost in a digital sample. Time of day, the seasons, and artificial lighting all have an impact too.

Some digital cameras provide a white-balance option as a counter to the color

COMPLEMENTARY COLORS

Color is the result of mixing one or more hues. Where there are no hues the result is black, and all hues together are white. To represent this mixture artificially, on the printed page, for example, or on a television screen, several color "models" have been devised and two are used most frequently: RGB and CMYK. RGB stands for the primary colors red, green, and blue, and mixtures of these in various degrees makes the other colors. RGB is used for television and computer screens, cameras, scanners, and binary devices. The CMYK model (which stands for cyan, magenta, yellow, and key plate—the plate that carries the black) is used for color printing. This model is used because ink cannot reproduce the range of colors provided by the simpler, but tonally more subtle, RGB model.

Fortunately, when you come to print your RGB digital image, it is converted to CMYK color automatically by the image-editing software or the printer's firmware (which accounts for the differences in the printed and onscreen image). RGB is said to be an "additive" model because the colors are added together to create others. CMYK is a "subtractive" model, the colors are removed by degrees to provide the required hue.

(*above*) If your camera provides red and yellow filters, they can be used to powerful effect in black and white photographs. In this image a red filter has deepened the contrast between sky and clouds

(*right*) Color conveys information which, though important, is sometimes second to mood as in this scene. The grayscale and added noise gives a gritty realism to the picture.

casting that artificial light can create. Some cameras offer red and yellow filters which profoundly affect the tones of black and white photographs. However, these effects can be simulated using image-editing software.

QUICK AS A FLASH

Light is your medium, but working with light can tax even the professionals. Too much and a picture's detail disappears into uniform whiteness, too little and there is no photograph. Your aim is to balance the available light to build your pictures, to create highlights, mood, and tone.

All but the very cheapest fixed-focus VGA digital cameras sport a flash unit. But it's fair to say that these usually tiny electronic flash systems are often underpowered and the results when using them disappoint many digital photographers. The unit is charging from tiny batteries which are also powering the camera. You can expect a built-in flash unit on a compact camera to have a maximum working distance of about fifteen feet. The manual that accompanies your camera will tell you the unit's working distance.

Most digital cameras offer several flash modes: autoflash, in which the camera decides

Night photography can produce beautiful results, but you must mount the camera securely to avoid the blurring that is inevitable with the long exposures required.

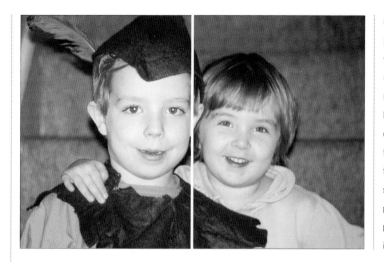

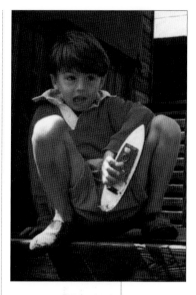

(*left*) The bane of low-light photography (when pupils are wider to admit more light), red-eye occurs when flash is reflected from the retina at the back of the eye. Many cameras offer a red-eye reduction flash mode which fires the flash fractionally ahead of the shutter so that the subject's pupils contract before the picture is taken and red-eye is avoided (left image).

whether to deploy the flash unit based on the exposure reading; and flash always on or always off. Switching on the flash yourself is useful when you need to light a subject that might otherwise be underexposed or thrown into silhouette, such as when shooting into bright light (this is known as "fill-in" flash). In these circumstances the camera's exposure meter reading would almost certainly indicate that flash wasn't required. Switching off the flash is necessary if you want to take time exposures—at night, say, with the camera mounted on a tripod and using very long exposure.

Reflected Glory

Wherever possible make the most of available natural light. If your camera's metering tells you that flash is required, try using a reflector (a large piece of white card will do) to direct light onto your subject. A reflector placed horizontally beneath a head and shoulders portrait will direct light up into the face, soft-ening shadows, smoothing wrinkles, and minimizing prominent features. Close-ups work better with reflectors too where flash might burn out detail. Indoors, position your subject near a window (one that admits indi-rect light), so that your back and the subject's face is turned to the light.

Blocking Noise

Outdoors, shoot your pictures mid-morning or mid-afternoon to avoid the deep shadows thrown by the overhead midday sun. In dim light use a tripod or position the camera firmly on a steady surface and use the timer to fire the shutter and avoid camera shake. Though digital cameras generally work well at long exposure times, some "noise" will begin to creep into the picture, though you can use fill-in flash to avoid it. If the camera features an EV or white balance option, use them to expose backlit scenes correctly in which the point of interest might otherwise be silhouetted or when shooting in artificial lighting conditions.

Fill-in flash helps to light a subject that would otherwise be underexposed and lacking detail. This is when flash comes into its own.

THE HUMAN EXPERIENCE

Photographing people makes for an inexhaustible supply of potential subjects, and the picture-taking starts right in the home with family and friends. With a new camera, a fresh set of batteries, and an empty data storage card you have the potential for some truly great people pictures.

People are endlessly fascinating, and pictures of people provide a truly irresistible fascination. Our brains are "trained" from childhood to recognize faces, to pick friendly or familiar faces from crowds, and to make a connection with faces and human form that is without parallel. For photographers, people provide an inexhaustible supply of material for interesting pictures, and for most of us that means we can find fantastic photos without even leaving the house. A good portrait picture preserves the moment enabling us to see beyond the obvious form and somehow glimpse the essence of a subject—though it's fair to say that the subject may not always like being preserved!

Pose the Question

During photography's early years, portraits were necessarily formal. Long exposure times required sitters to remain quite still for several minutes or more, effectively ruling out candid photography. The introduction of the Leica 35mm "miniature" and similar small cameras freed the photographer from the formal subject, and allowed pictures to be taken in all kinds of interesting situations. Candid shots—those without the subject's knowl-

edge—are explored elsewhere on these pages, but there is a mode of photography which falls between the rigidity of "formal" and the voyeur-like approach of the unobserved and more "candid" shot.

Informal pictures capture people in natural poses—which may or may not in fact be rigidly posed by you. A storekeeper leaning over the counter, a traffic policeman caught

Formal or informal, a portrait is a magnet for the eye. You want to see what, why, and when, who and where. Carry your camera and look for the moment that defines an experience, one in which the subject is contextualized within the confines of the image. It isn't easy and you'll discard far more images than you'll keep, but when it happens, you know you've got a great picture.

Children are endlessly fascinated by their world and it's that interaction with what's around them that makes for a compelling image—we want to know what it is the boy is about to dig up. Take lots of pictures of your kids so that they become impervious to the camera letting you capture the moment.

mid-gesture, the sentry in his box, family pictures of people sitting at the kitchen table, on sofas, or enjoying the deck all reveal something about the subject which is at once interesting and compelling.

Even today, when the majority of people are completely familiar with the camera, it remains relatively difficult to capture people at ease. They become edgy and nervous, unable to relax, or else wooden and stiff. Give your subject something to do to focus their mind away from the camera. A prop is a good way to help relax your sitter, suggest perhaps they hold a book, stroke a cat, or some such.

If you're photographing someone who isn't sitting for you, side-step potential hostility and ask permission! Most people will agree after a token show of objecting. By gaining

Proof that a snap of a family group for the album can be every bit as interesting as the "art" shot. Here the people are arranged in such a way that the eye is drawn into the picture. Height in the arrangement also plays a part and creates interest.

permission you can direct the subject into a "pose" that justifies your interest.

If you're taking a vacation picture of a friend posed alongside a landmark, try to create distance, and work up some drama between the two. Use the lens" widest setting, move far enough away from the landmark so that it isn't cropped, and stand the subject close to the camera. This will provide depth and enable both the person and the landmark to create their own space within the picture. Alternatively, keep your camera primed and ready and take the picture when your subject is animated, but with the landmark as a backdrop—effectively a frame—to the movement. Use depth of field and selective focusing (a technique described elsewhere in this book) to draw out your subject.

Eye to Eye

There is no greater impact than that of the subject making eye contact with the photographer. The effect can be dramatic, poignant, inviting, or starkly rebuffing, but you can be sure that those who see the picture will feel the impact whatever its apparent message. Ask

the subject to look directly at the camera. This might be difficult if your subject is self-conscious and shy, and even those who aren't will find it difficult to stare into the lens for longer than a few moments. You can overcome the problem by speaking to the subject just before you fire the shutter, ask again for them to look at the camera, or else capture their attention by making a noise or saying something unexpected.

If a face forms part of your picture and unless you're after a particular effect, always focus the lens on the eyes for maximum impact. Looking into the lens doesn't necessarily mean the subject should smile (though a glare might not be what you're looking for either!). Try to determine what it is about your subject that you and others might find interesting and arrange the face to tease out that particular element.

When palm-sized cameras became a reality in the 1930s, all kinds of truly amazing

Get up close when taking portraits and fill your image with the subjects (or else crop closely). There's nothing worse than squinting to make out a tiny pair of figures way off in one corner of the picture!

TWICE THE PICTURE

Here's a tip for a tense subject. Take your picture but then, immediately as the subject relaxes (because the moment has passed), take another picture. This second one could well be the picture you imagined in the first place.

pictures were taken of the rich, famous (and infamous)! Where people were familiar with, and aware of photographers lumbering about with unwieldy box cameras, they were caught off-guard by the new wave of photographers shooting candid pictures.

The Name is Bond...

Today the same is true. Your digital camera is probably smaller again than any conventional device you've previously owned. What's more, it'll either be silent, or can be silenced at the touch of a button. The potential for candid pictures is immense!

The first rule of candid picture-taking is simply to let you and your camera become familiar. If you're almost invariably seen holding a camera, no one will think twice when you use it, thereby enabling you to capture the moment.

If you find yourself in a one-off situation where familiarity isn't an option, then try using various blinds: misleading aiming, waist-level viewfinding, wide-angle framing,

CHOOSE YOUR VIEW

A high viewpoint narrows but slightly lengthens the nose, draws attention to the hair and forehead, and gives the face a triangular appearance. A low viewpoint tends to strengthen the chin, broadens but shortens the nose, and emphasizes the eyes and brows—but beware of nostrils!

WANTED!

A void head and shoulders portraits with the subject turned to face the camera unless your intention is to create a passport snap or a "wanted" poster. Instead, turn the subject so the picture captures a three-quarter perspective, narrowing the body. Tilt the head slightly so that the subject looks down the line of the shoulder into the picture. A pose like this will breathe life into a portrait and give it movement and interest.

or even a mirror turned at 45 degrees to the lens will get you the picture without the subject being aware. Misleading aiming involves your focusing at a point similar in distance to the subject. Hold the focus by retaining pressure on the shutter button, then turn to the subject and fire the shutter quickly before the victim is aware. Snap a second shot if your subject notices and decides to glare or confront you!

Candid Camera

With a preview LCD screen you can often frame and focus a picture away from eye height, enabling you to neatly conceal the fact that you're taking a photograph, or else a small mirror held at 45 degrees to the lens will turn your pictures through a right angle—you'll be pointing ahead but photographing to the side. Setting the lens to its widest wide-angle setting will enable you to point the camera

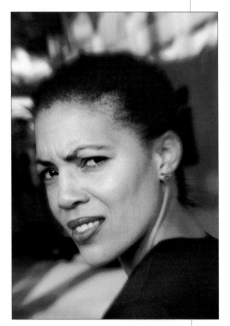

The classic head and shoulders pose with the subject's shoulder drawing the eye into the picture and up to the face. Here, a longer focal length has blurred the background and flattened depth to really lift the subject out of the picture.

away—ostensibly—from the subject you want to capture but while actually including them in the picture.

Interaction between several subjects equates to interest in a picture. When working with a group of people, arrange them so that there is a variety of angles and heights—even if that means someone kneels. Avoid a straight line-up treatment which makes for dull, flat pictures. Couples make great subjects. Let them touch to heighten the human interest, which is the essence of what you're attempting to capture.

Arrange multiple subjects so that they're framed by something solid—tree trunks, steps or stairs, a doorway or window. This will have the effect of joining and fixing the group in its own space, and provide a focus for the picture. Use your camera's wide-angle setting and exploit the lens' ability to fill the frame.

Little and Large

It's a sure bet that most of the children you meet and photograph will be smaller than you. Yet time and again you'll see photographs of kids who all but disappear into a corner of the picture because the photographer is towering over them. The secret, if there is one, is to get down where the action is (unless you're trying to make a virtue of a child's relatively diminutive stature to give impact and poignancy to a picture). Allow your camera to see the world as children see it. Look for unusual child-eye view angles, use a fast shutter speed (if your digicam lets you choose), and flash for action-stopping

pics. Try shooting from a low viewpoint—that is one lower than that of the child subject, so that you're looking up into the child's face, or else exaggerate the height difference by standing close and photograph the child from almost directly overhead.

If you have kids, accompany them to a birthday party and take your camera with you. Better still, take them to the park on a sunny afternoon, let them run off to play with others, and wait for the picture to emerge...

And here again we can see the potential for drawing the eye into a picture. While the subject is but a tiny part of the overall image, there's interest in the "layers" that arc horizontally across the scene, dividing it and heightening the visual impact and interest.

Point and

GETTING THE OUTSIDE IN

Step outside and you step into a world of possibilities, picture-wise. Landscapes are everywhere you look, even in cities, and buildings old and new are a joy to explore with a camera. And let's not forget the humble family seaside vacation, ice creams, donkey rides, and all!

From the moment you leave your home you're surrounded by landscapes that are potential pictures. A landscape can be the archetypal rolling countryside and scenes of farm buildings or a shot of distant office towers outlined against a dramatic sky.

If there's a secret to shooting landscapes, it is in rejecting the notion of including all that you can see into the picture in a bid to capture what you perceive as its breadth of scale. Instead, find a focal point that leads the eye into the scene and try to isolate a section of what you see—in a landscape, composition is vital, but by trying to incorporate the widest possible scene, you'll find that when the photograph is printed the lack of focal point results in a dull and empty picture. Try to avoid the obvious viewpoint. Raise yourself above the scene or get down low to tease out an interesting perspective.

The Light of Day

Time of day and the elements play a substantial part in the appearance of the landscape which is otherwise fixed. Patience will result in the picture you're looking for, and you may have to return to a subject when the light or the weather is better suited to the scene. Midday sun—the time when the sun is more

This picture (*left*) is a fascinating interplay of textures, light, shapes, reflections, and shadows; look for contrasts like this in any landscape shot, and you'll have a stunning image.

Point and Click

By focusing and exposing for the scene outside, then standing back from the window, this picture has a perfect frame. To achieve the same effect, stand close to the window and point your camera outside, squeezing the shutter release to enable the camera to focus on the scene and correctly determine a suitable exposure. Hold the shutter to "lock" the settings, then take a step or two back and release the shutter. You may need to crop superfluous window material from the picture

A delightful scene such as this (*left*) demands the rule of thirds for a balanced composition, but all the rules of exposure have been abandoned in order to capture the magnificent light.

or less directly overhead, results in few shadows and flat pictures. Morning and late afternoon sun casts deep shadows which reveal the texture in a scene and help you to build layers which draw the eye from the foreground to the background.

As you might expect, the seasons play an important part in the quality of light. During the summer months, your pictures will be well lit, but the light can be harsh, whereas in spring and fall, the sun is lower in the sky, shadows are deeper and the natural world is alive with color! Winter sunshine is thin and bright but beware of inaccurate exposure meter readings (and that includes automatic exposure digital cameras as well as those over which you have

Any device that will draw the eye into the picture will create interest. Here though, the railing has become almost abstract and yet it's the main source of interest within the photograph.

The wintry trees in this scene are, again, almost abstract. What matters in the image are the colors and textures which strike a chord in the viewer.

control). Snow scenes especially can easily fool your camera into overexposing and it may be necessary to make EV and white balance adjustments accordingly.

Second only to weddings, vacations present ideal opportunities for taking pictures. Simple snaps of families gathered together on the beach, kids making sandcastles, donkey rides, and brightly colored buckets and spades. Pictures like these are perennial favorites. They evoke lovely memories of endless summer days and strike a chord that virtually everyone can relate to. No day at the beach is complete without your camera and far from being clichés, these classic shots will live as pictures long after your attempts at high art have stopped embarrassing you!

Edifying Edifices

Photographing buildings is in many ways like photographing any landscape, the difference lies in the combination of attraction with purpose. All buildings have a function and a reason for their existence. Architects design buildings with a dominant aspect and by photographing this you capture the essence of what it is that makes the building interesting. Let your eye seek out the dominant features, and then move on to, and over, the supporting elements. A low viewpoint and a wide-angle lens setting will exaggerate these features and make for a very striking picture.

Opening the lens to its widest possible setting has resulted in wildly distorted angles in this picture of a windmill. However, the distortion emphasizes the mill's sails and points the eye to the second windmill on the hill at the right of the image.

CLOSE QUARTERS

Photographing buildings, it's natural to imagine that the best pictures will be those which include all or at least a substantial amount of the building in the picture using a wide-angle lens (or the wide-angle setting of your camera's zoom lens). But much of what good architecture is about is texture. Often getting up close and making an abstract of some small part of a building—worn bricks, scared stonework, an old rusted lock, or some such—will capture the flavor of a building in a way that shooting it as a whole never could. See pp. 62–65 for details of how to use your digicam up close.

Buildings can be impressive in their own right, or because of the way they fit into or contrast with their surroundings. Those constructed on an impressive scale can be difficult to work into a picture in their entirety and you might have to think of alternative ways to shoot them. Look for a reflection in a store window, a car's side mirror, or even a puddle for a different perspective.

Scale and Elevation

Alternatively, photograph the building from afar, filling the frame as far as you are able with your camera's zooming function and cropping out unwanted material when the picture is downloaded to your image-editing software. Work your way around the building, taking pictures that reveal interesting nooks and crannies. Consider how light falls and is reflected against its elevations; study the space around the building; use street furniture and passers-by to provide a measure of scale. Now move in close and pick out the building's details. Doors

Don't overlook a simple picture-postcard scene such as this one. Careful framing will help get all relevant detail into the image.

The distorted angles in this picture are what is known as "converging verticals." A wide-angled setting makes the building "lean" backward.

Although there's quite a bit of "noise" in this night scene of lit buildings (*right*), the artificial colors add emphasis to the hues from the buildings themselves and the whiff of steam from the center building is the frosting on the cake! The Arc de Triomphe (*left*) appears a see of calm and solidity among the bustling traffic in this long night exposure.

windows, steps and stairs, eaves, and the material of the building itself—bricks, stone, concrete, or whatever.

Landmarks are all very well, but it's the unfamiliar which makes an interesting picture when overseas. Street furniture such as road signs, electricity and telephone line poles, vending machines, mail boxes and phone booths, quirky

Textures and colors again. But with a longer exposure, they have created a softened tone for this image of pebbles on the shore.

SAND IN THE MACHINE

In the course of regular use, a camera will come into contact with all kinds of potential contaminants, but none is quite as bad as sand. Fine grains will work their way into every thread and combine with the grease intended as a lubricant to form an excellent grinding paste! It's possible to buy protective cases. Alternatively, save the clear plastic bags which wrap fruit, tying the bag tightly to keep out the sand.

A mixture of the natural and incongruous here makes for a splendid composition. The fact that the brash yellow of the sign contrasts splendidly with the intense blue of the sky squeezes extra value from a great image.

(*Right*) An adjacent building to the leaning Tower of Pisa, has deliberately been included in this photograph to make a comparison and show just how much the tower actually leans!

delivery vehicles, public transport (trams especially), and street markets with exotic fruit all create a picture of things which are—literally—foreign to our experience.

All Abroad!

Of course, when in Paris, take pictures of the Eiffel Tower; in London, Tower Bridge, the Houses of Parliament, Nelson's column and Buckingham Palace; in San Francisco, the Golden Gate Bridge, and in New York, the Empire State Building and the Statue of Liberty. But don't dismiss the everyday stuff. Look into a potential scene and try to isolate what it is that makes it different from your

own home territory, and then take a picture that emphasizes that difference.

Even the light itself can be different. If you live in a northerly clime and visit a region that's hotter, the light will be very different and will in some measure dictate the way that you approach pictures which might otherwise be familiar to you.

Like the photograph of pebbles on the opposite page, it is the soft tones and textures in this delightful picture of a rock pool that make for a worthy photograph.

AN INSIDE JOB

With a new camera and an eye for subject matter take a look around you: the home and backjard offers interesting shapes, colors, and textures, and the potential for a peek into the daily lives of your family and friends…

It isn't only charity that begins at home. With a new digicam fresh out of the box, your home becomes a veritable Aladdin's cave of picture-taking potential. Interiors, either "straight" or viewed from unusual angles (from the foot of a stairwell, for example), create interesting photographs, and the possibilities for lighting effects are many and varied. Outdoors, the fabric of the building can also provide plenty of potential.

Arguably more important than all of these is that the home is the focus of everyday life—your life, and that of your family. And there are few photographs more compelling than the simple act of people, young and old, going about their daily routines.

These Four Walls

Taking pictures inside your home can be difficult. There are extremes of light and space. If the sun is shining brightly into a room, it's easy to fool your camera into making the wrong choice of exposure, and using flash often results in harsh shadows, color casts, and red-eye if there are people in the shot.

Inside, try to look for ways to frame your pictures. By using say, a doorway or a window to frame the subject, you'll strengthen the overall composition and create an illusion of

Even a subject as simple as a few dishes on a table can catch your eye and attract your lens. Wander through your home looking for interesting shapes and arrangements—especially when shot from an unusual angle.

WIDER THAN WIDE?

Most compact digicams sport a lens that is the equivalent of a 35mm SLR's 50mm lens. This has a field of vision that roughly matches the human eye. However, pointing a 50mm lens into an average room will cause much of it to appear outside the frame. If your camera has a wide-angle setting, use it to include more of the interior. Equivalent focal lengths would be 35mm (the largest focal length that is considered to be wide-angle) or 24mm (generally wide enough for most situations indoors). If your camera can swap lenses and you plan to shoot interiors, plump for a 24mm or even a 20mm lens.

depth. It's important too, to ensure that the vertical surfaces in the room remain upright. Put the camera on a tripod and/or use its LCD preview screen if you find it difficult to keep everything upright using the viewfinder.

Placing people in a room will help provide a degree of scale, and if a person is seated, the room will appear to be larger. Position your subject midway across the room for the best effect. Take your picture from waist height; a shot taken at eye-level will include a lot of ceiling, and will unbalance the picture. Aiming the camera downward will cause the walls to lean into the frame. Take your picture from a corner to get in the most detail, or point the camera through an open door.

Unless your camera is equipped with a wide-angle setting, it can be difficult to include much detail into a shot of a room. Try squeezing yourself into a corner and shoot from waist height to provide scale and balance.

UP CLOSE AND PERSONAL

Zoom in to the world of the microscopic and see things from a different viewpoint with close-up picture-taking. Most digicams offer close focus of some sort and there are add-on lenses for those that don't.

Taking close-ups is easy if your camera has a macro mode—and many do. Macro photography is what close-up picture-taking is properly called. In this context "macro" is a focusing attribute which enables the lens to correctly focus an image inside the normal limit for its focal length. Sometimes this is achieved using an add-on macro lens, sometimes with on-board trickery but whatever the method,

close-ups enable you to take a "sideways" look at a subject, exploring it in an interesting new way which might otherwise be missed.

Of course, it's entirely possible simply to download an "ordinary" picture to your image-editing software, isolate a small section, and enlarge it but the results would not be anywhere near as effective as a true close-up picture. The reason, as those who have read

Getting in close, without disturbing your subject is only part of the secret of taking a picture like this one. This is where a good zoom or close-focus lens really comes into its own: not pulling distant objects into focus, but homing in on a near object and knocking its surroundings out of focus. The stunning effect is accentuated by the out-of-focus flower in the foreground. But when using autofocus, check carefully that the correct subject is sharp.

this book in sequence are by now aware, is that a digital image is constructed from pixels—a finite number of them. Enlarge a picture and you simply enlarge the pixels. Enlarge beyond a certain factor and the detail is lost—all that can be seen are pixels. In other words, there is no "hidden" information in a digital image—what you see is what you get.

No Soft Solution

So, true close-ups are generated by your camera, not your software. And just how close you can get depends upon the make and model. A mid-range camera aimed at the hobbyist market will generally offer a close-up facility focusing between one and two feet. Some cameras adjust the flash output too so that a subject focused at such a critical range will be properly lit and exposed. Cheap cameras or older models may not have a close-

Using a powerful zoom or close-focus lens, a similar but equally striking effect to the butterfly image (*opposite*) can be achieved by knocking even some of the subject out of focus, and just focusing tightly in on the face, or the eyes. This technique is useful for human portraits too.

up facility (though even at this end of the camera spectrum most do) and those at the other end of the scale, some of the expensive "pro" cameras offer close-up photography at focusing distances of just a few inches.

One thing is certain, whether the distance is one foot or just one inch, if you're using a

HOW CLOSE IS CLOSE?

Close-up (or macro) lenses aren't measured in focal length in the same way normal lenses are. Instead a "diopter" rating is used. Diopter is a measure of magnification and usually diopter lenses are rated on a scale of between +1 and +10. +10 is used for really close-up work.

ADDING VALUE

If you want to get really close, you'll need to acquire add-on close-up lenses. Even if you're using a fixed-lens (not fixed-focus which is something else) compact camera—one which has a lens that can't be removed—you can probably buy and use one or more close-up lenses to suit. Many third-party accessories manufacturers offer lenses for digital cameras. Visit your camera manufacturer's web pages for details of add-ons, or use a search engine and search for something like +lens+closeup+digital. Close-focus lenses look very like magnifying glasses without a handle (because that's just what they are!) and as well as fitting to the camera they can be attached to each other to sum their diopter values. That is, if you add a +10 and a +5 diopter lens you'll get a +15 diopter lens. Be aware that combining lenses in this way may result in some small degradation in the results.

point-and-shoot compact camera, what you see in the viewfinder will be far removed from what the lens is seeing. This phenomenon—known as "parallax"—occurs because of the distance between the position of the viewing lens and the exposing lens. The few inches that separate these lenses on non-SLR cameras have little or no effect on framing when you're taking normal pictures, but draw near to the subject and the effect increases the closer you get.

Extreme Measures

Almost all compact cameras provide opaque framing guides (also known as correction, parallax, or close focus marks) visible in the viewfinder to help you frame at various distances. However, these might not assist in extreme close-ups. Instead, you must resort to the LCD preview screen to see what the lens is seeing and frame accurately (indeed, many cameras switch on the preview screen as soon as you enter close-up mode). Use the framing guides to position your subject within the viewfinder, so that the resulting picture shows the subject more or less where it should be.

The zoom feature won't let you get very close but the depth of field will be greater—although enlarging the picture to get the same subject will not yield the same detail as with a macro feature.

Cameras with a "macro" (close-up) feature let you to get very close a subject, but the "depth of field" will not be great (the foreground and background will be out of focus).

Nearest and Dearest

1 Good lighting and sharp focusing is essential for a quality close-up picture. Lighting can come from the camera's own flash or from external lamps—a couple of anglepoise lamps perhaps (though compensate for the tungsten bulb by using your camera's white balance function).

2 Mount the camera on a tripod. Switch on its close-up mode and position it so that the subject is framed in the way that you want. Position external lights if you're using them. Switch on the camera's timer function. This will enable an exposure to be made without inducing camera shake from the shutter button.

3 Squeeze the shutter release to lock focus, then fire the shutter. Move back so that your shadow doesn't obscure the subject, then stand still so that camera is affected by vibration (which will appear in the picture as fuzzy focusing).

4 Sharpen the image once it's downloaded to your image editor using the techniques covered elsewhere in this book.

FIELD TRIP

When using a close-up lens the depth of field will be reduced dramatically—possibly to as little as 15mm. This can have a significant impact on your picture. If you're shooting, say, a flower at close quarters, the depth of field may not even be sufficient to keep the whole flower in focus. You might find that while the petals at one side are pin-sharp, those at the side are a complete blur. This can make for creative interest but it can also be simply irritating! To partly overcome the problem, use lots of light to enable you to use as small an aperture as possible. If possible, position your subject on a stiff sheet of white paper to throw light up and on to it. If you're shooting outdoors, in a meadow for example, you can use a piece of stiff white paper as a light deflector by locating it to the side and at an angle to the subject.

If you follow the steps outlined on this page carefully, you should achieve high-quality, close-up shots that give sharp detail and accurate color.

HOW YOUR GARDEN GROWS

As the seasons shift and change, you'll have limitless possibilities for imaginative and stunning photographs. But each new season will present fresh challenges, as well as new blooms and fauna.

The garden is a great hunting ground for photographs. Obviously, the seasons will largely dictate what's of interest in any garden, but also provide a shifting, ever-changing backdrop to your photographs. During the summer, there's fauna and flora in abundance, children playing on the grass, older family members dozing in chairs, and pets frolicking. Avoid the midday sun which casts few shadows (and results in flat, lifeless pictures), and shoot your photographs in the morning or late afternoon when the sun is at an angle in the sky and you can discover interesting nuances of light and shade.

Snowdrops and F-stops

During winter, and especially in the snow, the landscape of the garden is transformed dramatically. Snow reflects and boosts the available light. Your camera will expose incorrectly, and it's important to adjust using its EV (Exposure Value) function (for more information see pp. 44–45) which manually compensates for over- or underexposure. Adjust by two EV stops to ensure that snow appears white; otherwise it will be captured as a mid-gray. Similarly, mist and fog requires EV compensation of up to two stops to expose correctly and retain the white of the mist.

Using the macro feature on your camera lets you capture the splendid colors of nature; and of course in any image-editing software those colors can be further enhanced.

This photograph of a typical meadow uses the brook to lead the eye to the focal point of the image. Note also how the branches in the foreground add drama to the composition.

Keeping as low as possible to the level of borders of brightly colored flowers helps to bring out the amazing variety of color, shape, and size of the plants.

The muted tones and interesting shapes of the branches and leaves of this tree provide an enticing foreground to the country scene beyond.

White Out

Indoors, it's more than likely that you'll be shooting under artificial lights: either fluorescent striplights or conventional tungsten bulbs. Either will add an unwanted color cast to your pictures, in this case reds or greens. Preview a shot with the on-board LCD and, if you find that it has a blueish or greenish cast, use your camera's white balance functions to compensate for the artificial lights. This function of your camera is also particularly useful in very white sunlight or in snowscapes. If your camera is without a white balance option, you can simulate the effect using image-editing software once you have downloaded the images onto your computer.

Shots of landscapes covered in a blanket of snow are often disappointingly gray (*above*) when you see the results. Most mid-range digital cameras feature white balance adjustment. This makes an allowance for the amount of white light, so that the image becomes less gray and the whites purer (*left*).

PETS AND OTHER ANIMALS

Animals provide great potential for photographers and those using a digital camera have an added advantage: no film to waste while taking the endless shots required to capture the "right" picture! Start by practicing with family pets and work your way up to bigger and wilder animals.

Everyone's heard the old thespian saying about "never working with children and animals," and there's a good reason for its passing into common currency (especially when applied to the latter category): animals are unpredictable! Even photographing loveable and friendly pets can be fraught with the unexpected. But photographing animals is fun and their behavior can provide magical pictures—which is why actors dislike working with them so much—no actor wants to be upstaged!

So haul out your digicam, switch on the flash, and get to work around the house photographing your family pets. You know by now that, as a digital photographer, you have an automatic head start—you can shoot as many pictures as batteries will allow without wasting film, and continue until you get the picture you're after.

Good Behavior

Start by watching the animal in question—say, a cat or dog—and note the details of their

Even a pet cat can be chivvied from his lair as a subject for a photograph! Invest time watching your pets in the home and garden so that you can determine their habits. Mount your camera on a tripod and settle yourself for a wait. When the picture comes along, you'll be prepared.

Dogs can make excellent subjects for photographs. Unlike humans, they're not aware of the camera and therefore don't exhibit any self-consciousness—they just strike a perfectly natural pose.

behavior, where and why they come and go. Both cats and dogs have favorite spots where they like to curl up for a nap. Cats generally prefer to raise themselves off the ground and choose somewhere warm, though many will also come and sit on a piece of paper for no apparent reason if you put a sheet down on the floor. Dogs (if they are allowed) enjoy sofas, beds, or a big cushion, a spot on the hearth before an open fire, or a stretch beneath a warm radiator.

Know Your Prey

Get to know their favorite places and you have a likely stalking ground for great pics. Choose your location, sit quietly with your camera, and wait for the picture to hove into view. Wide-angle and zoomed lenses work equally well for different reasons, and you can always crop to compensate for weak composition afterward. The effort will be in capturing your pet at his most endearing, when he's displaying a human-like trait or action.

Caught in the Act

Many animals enjoy performing tricks, cats like to catch small items that you throw for them, and will endlessly chase a bobbin or some such attached to a length of string. Dogs are altogether easier creatures to train, and will happily sit down, rollover, hold out a paw, or balance a square of chocolate on their noses

while you take a picture. Some dogs (especially the smaller breeds) will even do spectacular tricks like walking on hind legs.

The Right Way

Remember though that the secret of a great pet picture lies in encouraging your pet to do whatever catches his personality. Tricks are fun, but unless they say something about the pet, the potential for poignancy is lost. If you're trying to photograph small animals, fish, or reptiles—essentially those that are housed in glass or plastic tanks—beware of reflections from the tank, especially if you're using flash. A good idea is to set the camera on a tripod at a slight angle to the tank, and use the camera's timer to take the picture for you once you've checked for composition and focusing to avoid catching your own reflection. Also, a polarizing filter will cut glare (hold it in front of the lens if your camera can't use filters).

There are super shots to be had outdoors too, but to find them you'll have to monitor the animal's behavior. Patience will reward

you with the best picture, and your camera's zoom will get you closer to the action.

Open Forum

Zoos and animal parks are perfect starting points for larger (and possibly wilder!) animals. Photographers often struggle to shoot zoo pictures without including the cages in the shots. Digital photographers have no such problems. Using the photo editing techniques discussed later, it's possible to remove cage bars and other artificial obstructions, which would otherwise ruin a great photograph.

A photograph like this is all about simply being in the right place at the right time—often entirely by accident. Be sure to carry your digicam with you wherever you go with fresh batteries and free space on its memory card so that you never miss a picture.

On the other hand, a simple trip to your local zoo or wildlife safari park will turn up lots of photographs like this. The inmates are entirely used to having strange people point cameras at them! And of course with some deft image manipulation any annoying artificial artifacts (*left*) can easily be removed (*right*).

But conventional techniques will work too, so position the camera as close to the cage as is practicable. Depth of field will ensure that it "melts" into the shot. Use your camera's zoom lens function to enable you to span the safety barriers between you and the wilder inmates. A wide-angle setting is useful when photographing creatures indoors. And don't forget that the zoo is full of watchers as well as the watched and some of the visitors are every bit as rich a hunting ground as the inmates.

A fast shutter speed will stop action and enable you to capture birds in flight, though you might shoot many pictures before you get the "right" one.

These ducks have become almost abstract shapes within the picture, which makes it an intriguing composition.

SPORTING CHANCE

Next time you go to watch a football match or cheer on your children at the school sports day, don't forget to take your digital camera. There's a wealth of picture-taking possibilities at every event.

Sporting events present fabulous opportunities for picture-taking. Indoors or out, solo, in teams, behind the wheel, mounted on horseback, with a bat and ball, a rod, or whatever, there are people, there is interaction, moments of high drama followed by periods of extreme concentration—all grist to the photographer's mill.

You can approach sports pictures in two ways: if you're a fan of a particular sport, say, football, take along your camera whenever you set out to watch a match and log the game as it unfolds; alternatively, and for those who aren't great sports fans, think of sporting

If you've ever noticed professional photographers at a sports event, you'll have seen that they use very long lenses in order to get closer to the action. Many digicams offer a zoom of some description and though these are usually very modest compared with the professional models, they can help fill the frame and magnify the subject matter.

Panning a picture—moving the camera in time with the movement of the subject heightens the impact and makes for a dynamic picture. The technique isn't difficult but requires practice. As a digital photographer you have a distinct advantage: you're not wasting film! If the results don't please you, discard them and take some more.

Mount the camera on a tripod, lock the focus on a point at which the subject(s) must pass through, and take a several pictures either one immediately after another or at intervals. The result is a striking action and time sequence, which truly conveys the atmosphere of the event.

events simply as opportunities for taking great pictures of people. In fact it's almost certain that you've already taken pictures at sports events as a way to record the event for posterity—school sports day perhaps—but without really considering what you're doing as "photography." Now, you can combine the amazing features your digicam provides with your burgeoning skills as a photographer to record these events for your family and friends but while also taking pleasure in getting the best picture you can.

Unless you're photographing a chess match in which case no one will be able to tell, a fast shutter speed will stop the action and capture some truly amazing pictures. This type of picture is especially effective at events at which capturing the natural grace of the body would otherwise be missed.

Using a slow shutter speed or moving the camera as you fire the shutter will result in a blurred picture. However, this can be used to dramatic effect.

PLANES, TRAINS, AND AUTOMOBILES

We are surrounded by public and private transport of all kinds some of which—arguably—is attractive enough to warrant a picture! Your own vehicles, a vintage motorcycle perhaps, a steam train, or a yacht in full sail are all excellent subjects.

Endless pictures of a customized Ford, with gleaming paint work and whitewall tires, may bring back some memories for you, but they're very definitely best kept private! If you absolutely must take pictures of your motorized pride and joy, then now (i.e., putting into practice what you've learned in this book) is the time to do it with artistic aplomb. That way if the pics fall into the hands of those who might otherwise be entirely uninterested (your wife/children—and no apologies for assuming that it is the male who might be tempted!) they will have at least have some esthetic merit…

In fact pictures of cars, airplanes, steam trains, and all kinds of other weird and wonderful vehicles account for the bulk of professional photography sales around the world and, with care, you can ensure that transport pictures are interesting to look at for their own sake as well as, in future years, being a hideous reminder of your youthful taste in cars!

Bring out the Best

The key with photographing inanimate and sometimes overfamiliar objects is to look at what makes them familiar, or attractive, and to find ways of accentuating those unique features. Try different viewpoints, close-up details of radiator grilles and badges, waist-high shots along the hood, or with a single detail—

Smile, please: the gorgeous curves and smiling radiator of this classic car are ideal subjects for the imaginative photographer. A flattering setting looks good in both, but the image on the left benefits from the viewpoint and the use of a wide-angled lens to draw out the most prominent feature.

h as a headlight—in focus. Or try using ⁣erent lenses or settings: a wide-angle lens to ⁣ort the view from close up, a zoom to ⁣phasize a detail from close up. A stunning ⁣ation helps: an English stately home would

make a fitting setting for a vintage Jaguar or Rolls Royce; as would an urban setting for a classic sports car. And with the editing techniques we'll explore later, you could add some motion blur for extra dynamism!

LONG AND WIDE

The standard 50mm-equivalent lens is geared to everyday tasks, but lenses of longer and shorter focal lengths—or digicams sporting zoom lenses—are often better suited to particular tasks. So it is when taking pictures of vehicles. Interiors require the widest possible wide-angle settings to capture as much detail as possible. Exteriors also benefit immensely from a wide-angled lens setting which tends to exaggerate angles and can make an otherwise dull "three-quarter" shot of our motor car (*opposite*) for example, look far more dynamic.

Long lenses too have their part to play. Zooming will fill the frame for a more dramatic picture and it will get you closer to the action—from an airport observation area or railroad platform for example.

Boats make ideal pictures, with a little imagination and good composition. Their elegant curves and variety of textures (wood, rope, sail cloth,

The Digital Darkroom

Time was (and it was not so long ago) when photographers were required to carry around a heavy wooden camera on an unwieldy tripod, boxes of delicate glass plates, bottles of crude and sometimes dangerous chemicals, and a special tent that doubled up as a darkroom for developing "in the field." Fortunately Kodak's box cameras ("You take the picture, we do the rest") simplified picture-taking, and the digital cameras of today continue that tradition, freeing your attention so that you can capture the picture you want without being overly concerned with the mechanics of exposing, developing, and printing. A desktop computer is your digital darkroom. You work in complete daylight, and enjoy instant results, but your mastery over the resulting images is absolute.

SOFTWARE

The digital darkroom is, in reality, image-editing software running on a computer. Your pictures are already "developed" inside the camera, but download them to your computer, fire up your image-editing software, and your "darkroom" is ready…

Until you print a picture from a digital camera, it exists as a digital file, just like a wordprocessor or spreadsheet document. And, just like those other computer files, dedicated software is available to manipulate, edit, enhance, and print the file. All but the very cheapest cameras come with editing software for you to install on your computer. Sometimes this software will include the software for linking the camera and the computer to transfer the files; but it is rarely as sophisticated as third-party software.

Shop Smart

The leading image-editing software by far is Adobe Photoshop. Available for the Apple Macintosh and Windows PCs, Photoshop is a feature-packed program which, in experienced hands, can produce truly amazing results.

The disadvantages, however, are that many of Photoshop's features are confusing for novices, the interface is anything but intuitive, and the price is way beyond what the majority of home users might consider paying. Indeed, you can buy a good-quality, mid-range camera and editing software for what you'll pay for a copy of Photoshop. The program is absolutely without parallel in the marketplace, but unless you're a professional, or an amateur with a large bank balance, it might be better to look elsewhere.

One alternative to Photoshop is Adobe's cut-down version, Elements. It is the latest

Photoshop Elements' tool kit hides an amazing array of options beneath each of its buttons.

Marquee	Move tool
Lasso	Magic wand
Crop tool	Text tool
Rectangle tool	Linear gradient tool
Airbrush	Paint brush
Paint bucket	Pencil tool
Eraser	Impressionist brush
Blur tool	Sharpen tool
Sponge tool	Smudge tool
Red-eye brush tool	Dodge tool
Rubber stamp	Eye dropper
Hand tool	Magnifier
	Foreground/Background color
Set to black and white	

addition to Adobe's range of image manipulation software. Photoshop Elements uses similar tools to its big brother.

It's Elementary

Targeted at the keen amateur, Photoshop Elements is geared to getting the most from digital camera images and among the tools and filters used to correct the kinds of problems you're likely to encounter, are features such as color correction, red-eye correction, merging backgrounds, constructing panoramas, straightening skewed pictures, and there's an integrated image browser too. The program also features a real-time compression option that enables you to squeeze the size of the file while viewing the effect on the image.

Pro Plus

For the PC only, one of the better-known programs—certainly the best value—is Paint Shop Pro, by Jasc Software. Similar in many ways to Photoshop, Paint Shop Pro (PSP) offers a complete range of image-editing tools allied with an easy-to-use and intuitive interface. The program began life as a shareware offering, and you can still download, install, and run the latest version for 30 days before deciding to buy it. PSP is also often available on the CDs that accompany digital photography magazines.

The program features many dedicated digital photo tools including a scratch filter, red-eye removal tool, and auto contrast and color balance enhancement. You can import pictures directly from your digital camera, and there's a built-in image browser.

Magnifier

Crop tool

Rectangular marquee

Magic wand

Paint brush

Color replacer

Palette knife

Picture tube

Paint bucket

Pencil

Object selector

Move tool

Deformation

Move tool

Lasso

Eye dropper

Clone brush

Smudge tool

Eraser

Spray can

Text tool

Preset shapes

And the Rest

If you have an Internet connection, try searching the Web for free downloads and shareware offerings. Many digital imaging and computer hobbyist magazines feature demo software on their cover-mounted CDs, too. Experiment until you find an image editor that suits you—when you do, you'll be amazed at the possibilities!

Paint Shop Pro has most of the tools the novice or semi-professional user will need. However, Mac users beware, this image-editing software is only available for PCs.

STEP 1—SHARPEN & CONTRAST

It's time to open the door to your digital darkroom. Start with some simple editing—enhancing sharpness and adjusting contrast—and you'll soon be creating complex photomontage images, and exploring time-lapse picture-taking!

As you now know, digital images consist of many thousands of pixels and each one is individually addressable. What that equates to is the ability to edit at the pixel level—the most basic—and enjoy complete control over your images. If you were a skilled artist, you could actually "paint" whole new features into your pictures a pixel at a time—people, buildings—whatever! For the rest of us, those with modest artistic ability, you can improve sharpness, enhance contrast, correct flaws in lighting and composition, tweak composition, edit out unsightly or unwanted "features," crop for best effect, and much, much more using the tools provided by image-editing software.

Tools for the Job

A program such as Photoshop Elements or Jasc's Paint Shop Pro provides incredible control over an image with comprehensive software toolboxes which pre-empt your requirements, and require little effort to get good results. So let's start by using, say, Paint Shop Pro (hereafter PSP) on the PC, to sharpen and adjust the contrast of a typical digital photograph. You won't believe how easy it can be!

Sharpening

1 Fire up PSP by double-clicking its shortcut on the desktop or selecting it from the *Start* menu. When the program is running, press *Control > B* to summon the image browser. Navigate to the image you want to enhance using the folder on the left, then double-click the image thumbnail in the right-hand window to open it.

2 This picture of a train has the potential to become a very nice photograph. The wall creates a baseline from which the train leads the eye into the picture, and the tracks beyond continue the theme. The train bends slightly to the left, drawing the gaze into, rather than away from the image. But the nondescript sky and the slight fuzziness in some areas, together with late afternoon lighting is spoiling the overall effect.

3 Pull down the Image menu, and from the *Sharpen* submenu select *Sharpen*. The image is sharpened slightly.

4 At the *Sharpen* submenu again, select *Sharpen More*. This time, the sharpening effect is dramatic. What happens if you apply the filter again? Try it. The image becomes almost pixelated. Press *Control-Z* once to undo the last edit (the second *Sharpen More*). Though the sharpened image appeals to the eye, the train is beginning to lose resolution, its once-smooth edges are now noticeably jagged. Fortunately, you can selectively sharpen an image. So let's start again.

5 Select *Revert* from the *File* menu to abandon all changes. Without selecting anything, apply the *Sharpen* filter to the entire image. Click on the *Freehand* tool and draw around the wall and apply *Sharpen More*. This throws the wall into relief, giving it an almost organic appearance. Applying even this simple filter has markedly improved the picture.

Contrast

1 The camera has captured smoke trails from the engine but the late afternoon sun has produced a hazy effect. Fortunately, this can be improved with a little contrast tweaking. Make sure the picture is selected (by clicking it), pull down the *Colors* menu and, from the *Adjust* sub-menu, select *Brightness/ Contrast* (or simply press Shift-B). The *Brightness/Contrast* dialog box appears.

2 Experiment with the slider bars. The thumbnails above each will change as you make adjustments. Click the *Auto Proof* arrow (to the left of the "proof eye" between the preview windows). Now when you move the sliders, the picture itself will change. Here, a couple of notches of brightness and contrast is enough to cut the haze and help give the picture some zing. Click OK.

3 Back at your picture, press *Control-Z* to undo the adjustments if you decide you were too aggressive with the filters (which is easy). The secret is to experiment. Nothing is altered irrevocably until you save and even then, many image editors will allow you to undo changes. Now all that's needed is a bit of blue and some clouds in that sky. We'll get to that later!

STEP 2—SELECTIVE FOCUSING

Almost all hobbyist digital cameras offer autofocusing as standard—you simply squeeze the shutter button and the camera does the rest—but it's surprising just how often the camera can be fooled. However all is not lost with a poorly focused image if you have access to image-editing software.

While today's digital cameras are light and compact, and many feature complex software algorithms to counterbalance external camera shake (i.e., caused by you as you hold the camera), it's still entirely possible to produce images that are not absolutely pin sharp. Earlier we looked at a simple method to improve the sharpness of your pictures, but there are many ways to counter the problem of poor focusing and we'll now look a little more closely at the tools on offer in image-editing software.

Hazy Routes

1 Along with the *Sharpen* and *Sharpen More* filters, which merely increase the intensity of pixel tones where light and dark edges meet, Most image-editing software features *Unsharp Mask* (or something similar). This feature can work wonders with fuzzy, hazy images. Here we've opened the image in PSP.

2 Summon the *Unsharp Mask* dialog box by pulling down the *Effects* menu and selecting it from the *Sharpen* submenu.

3 The preview windows show "before" and "after" effects. There are a number of settings on the dialog that you can adjust (play with!), gauging the effect of each in the preview windows (and on the original image if you click the *Auto Proof* arrow).

4 *Unsharp Mask* is a filter that increases further the intensity of contrast between mid- and high-contrast pixels. The *Radius* field specifies the number of pixels affected at an edge. *Strength* and *Clipping* denote the measure of intensity applied and the break-off point for pixels that are not affected by applying the filter.

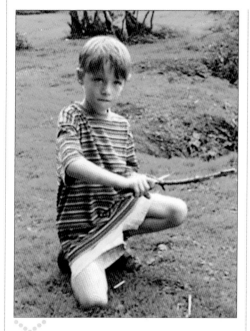

5 Play with the controls until you become familiar with the effect each has on your image. Generally, a *Radius* of around 2.00, together with a *Strength* of 100 and *Clipping* set at 5 (i.e., the default settings) will give good overall results. Click the *Reset* button at the right of the *Help* button to return to the filter's defaults. The finished result should be an image like this, (*above*).

Further Clarification

1 Another excellent tool for enhancing sharpness also provided by Paint Shop Pro is the *Clarify* tool. Open your fuzzy picture in PSP.

2 Pull down the *Effects* menu and, from the *Enhance* menu, select *Clarify*. Picture sharpness is enhanced in a way that sometimes (depending upon the picture) even image-editing software experts would find hard to match using "traditional" tools such as the *Unsharp Mask*.

3 Of course there's a downside: *Clarify* works only across an entire image; you can't apply it selectively. Also it will only work with grayscale and images with a 24-bit color depth, although there is a way around this...

4 Simply increase the color depth of the image. Apply the *Clarify* tool and reset the color depth, if required. This quick fix would be appropriate for images with low color depth, intended for the Web.

STEP 3—CLEANING UP THE IMAGE

A vanishing act is easy when you manipulate your pictures with image-editing software. Remove noise, artifacts, and even undesirable features with the swish of a mouse and the click of a button…

Remarkably, digital images can be blighted (and sometimes enhanced!) by noise—not anything you can actually hear, but speckles in the picture caused by (among other things) low light levels. These appear as pixel-sized spots of color throughout the image. Removing noise (or even adding it for effect—more of which later) is straightforward, and many image-editing packages provide specific tools to do just that. It's a bit like deliberately generating a grainy photograph in conventional photography.

Stepped Edges

Artifacts occur in JPEG pictures which have been edited and saved many times. During every save the JPEG compression algorithm is applied, and eventually the picture begins to deteriorate and the edges of the subject matter appear become increasingly jagged—these are known as artifacts.

Speckled Image

1 With a yen to remove noise speckles, open the troubled image (here in Paint Shop Pro) pull down the *Effects* menu and select *Despeckle*.

2 PSP automatically removes detectable noise within the image. Some noisy images respond very well to this algorithm, others poorly. If the latter holds true in your case, try this…

3 Access the *Effects* menu again and select *Edge Preserving Smooth*. A dialog is displayed.

5 Sometimes, applying noise filters can have unexpected results (severe filtering can remove desirable information from a picture). Use *Control > Z* to undo the effect and try again using less smoothing until the balance is just right.

4 Use the buttons to increase or decrease the amount of smoothing according to the result in the preview window. Click *OK*.

1 Jaggies appear in digital pictures that have been overly compressed. JPEGs are especially vulnerable to this side-effect (known in JPEG parlance as "artifacts"). To reduce JPEG artefacts using Paint Shop Pro first open the image you want to correct.

2 Pull down the *Effects* menu and, from the *Enhance Photo* submenu select *JPEG Artefact Removal*.

3 Undo (*Control > Z*) will restore your image if the result is not to your liking, otherwise *Save As* to make a new copy.

Time for Change

1 The *Clone* (or *Rubber stamp* in Elements) tool is ideal for removing unwanted features from an image, in this case an unsightly television aerial on the thatched roof of this cottage.

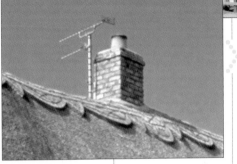

2 Open your picture and zoom in on the aerial. Don't get too close however; otherwise it becomes difficult to see how the cloning is blending in with the surrounding picture.

3 Select the *Clone stamp* tool. Right-click (or shift click) an inch away from the aerial to specify a source for the *Clone* tool. Now move to your target, in this case the aerial, and press and hold the left mouse button. Crosshairs appear at the source point.

4 Move the *Clone* tool over the aerial so that it is covered by the material from the image picked up by the crosshairs. Continue until the aerial is "removed."

5 If it becomes obvious you've cloned from a specific area, try selecting a different source, clone, select again, and so on, to break up the result.

STEP 4—ADJUSTING COLOR

Our eyes are alive to the possibility of color, and a lustrous, color-saturated image captures a subject like nothing else can. Colors create mood, and colors imbue digital images with a reality that they might otherwise lack…

Unlike conventional photographs, the color in digital images can be manipulated in order to tease the most from a picture. You can correct color casts from artificial lighting and selectively increase color saturation to add emphasis to a picture.

That's All, Folks

It's important to realise though, that making corrections to color cannot add detail where none existed before. With a conventional negative, dodging and burning techniques (exposing more or less of sections of a print to the projected negative image) can uncover detail previously lost in shadow. A digital image has no secrets—what you see is what you get. The advantage is that each pixel can be changed to improve the image. The disadvantage is that unless you're skilled at drawing, you can't add features where none exist.

So improving color starts with the camera and the exposure—use the features of your camera such as white balance and exposure compensation, review each picture taken immediately, and reshoot where possible. That way, you'll have the best possible exposure which can be enhanced further in the digital darkroom.

Saturate to Accumulate

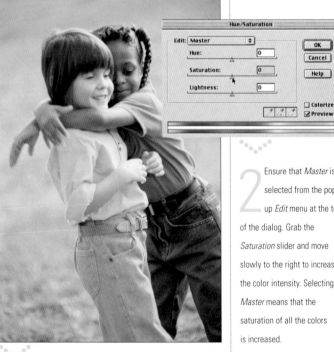

1 Contrast adds vitality to colors, but it's also possible to increase their intensity too much (just as you can turn up the color on a TV). Open your image (here in Photoshop Elements), pull down the *Enhance* menu and, from the *Color* submenu, select *Hue/Saturation* (or press *Control > U*). The *Hue/Saturation* dialog is displayed.

2 Ensure that *Master* is selected from the pop-up *Edit* menu at the top of the dialog. Grab the *Saturation* slider and move slowly to the right to increase the color intensity. Selecting *Master* means that the saturation of all the colors is increased.

3 You'll find that while some colors respond well to this adjustment, others such as skin tones don't. Access the *Edit* pop-up again and select *Reds*.

Add Life

1 Breath life into flat, washed-out images by making simple adjustments to the contrast. It's an easy tweak in almost all image-editing software, and the first point of call to brighter colors.

2 Open the picture with an image editor (here PSP). Pull down the *Colors* menu and select *Brightness and Contrast* from the *Adjust* submenu (or press Shift-B).

4 The preview windows on the dialog box give a flavor of what to expect, but it's back at the image proper where you'll see the effect of the changes. Use *Control > Z* to undo overly zealous adjustments and *Shift > B* again to summon the dialog for another go.

4 Use the *Saturation* slider to make skin tones more natural by moving to the left slightly. As you adjust, you'll see the picture itself change (if the dialog's *Preview* checkbox is selected). Click *OK*.

5 As always, use *Control > Z* to undo changes and return to the *Hue/Saturation* dialog to try again if you need to. Play with the colors until you begin to get a feel for balance—remember: the image remains unchanged until you save!

3 Make small adjustments to contrast by typing a new figure into the *Contrast* field or click on the pop-up slider and move left or right to suit.

STEP 5—ADJUSTING BRIGHTNESS

From simple overall brightness and contrast adjustments to the delicate tweaking of midtones, shadows, and highlights, image-editing software will enable you to save pictures that otherwise would be ruined by poor exposure...

How many pictures have you taken that were spoiled by being under- or over-exposed? Although it's possible to manipulate conventional negatives at the processing stage in order to lighten or darken them and improve contrast, and also to edit the resultant prints using dodging and burning techniques, the processes require that you do your own developing and printing and that means a darkroom, enlarger, and lots of other expensive and unwieldy equipment!

All Change

Digital images of course, are far easier to manip-ulate. Every pixel can be changed. They can be brightened, made darker, and changed in color to suit your requirements and improve the resulting picture. In fact, improving exposure begins at the camera, where EV compensation and expo-sure locking (controls that enable you to alter the camera's exposure settings relative to its metered measurements) are a significant aid in correctly exposing a picture.

Comprehensive control, however, begins when the picture is opened in an image-editing program such as Photoshop Elements. Everything from simple changes in overall brightness and contrast to complex histogram-based adjustments are available.

Filling Station

1 Because it's oriented toward digital photographs (rather than digital images that have been drawn or scanned), Photoshop Elements provides camera-like lighting tools and filters which echo those available in the real world.

2 Launch Photoshop Elements and open a poorly exposed image.

3 First step is to darken the background slightly in order to strengthen detail. Select the *Lasso* tool and carefully draw around the subject. Try to keep the marquee either on or inside the subject's edges. Press *Shift > Control > I* to select the background.

4 Pull down the *Enhance* menu and select *Adjust Backlighting*. Click on *Preview* to select it, and use the *Darker* slider bar to deepen the tonal range of the selected background. Make gradual adjustments. Click *OK*.

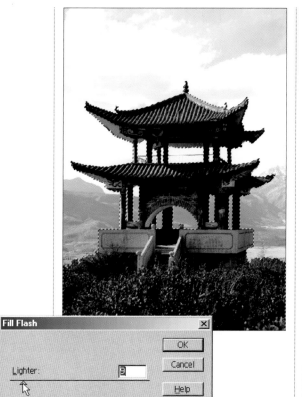

Fill Flash

Lighter:

OK
Cancel
Help
☑ Preview

5 Press *Shift > Control > I* again to select the foreground/subject. Select *Fill Flash* from the *Enhance* menu. Use the *Lighter* slider bar to increase the brightness of the selected subject. Make sparing adjustments—a little goes a long way!—so that you don't bleach out detail. Click *OK*. Save the result.

EV ADJUSTMENT

Before making an exposure, the metering system within a digital (or conventional) camera assesses available light and sets the aperture and shutter speed accordingly. This happens in a fraction of a second as you squeeze the shutter release button and, if there are subjects of strong contrast in the scene, the camera can easily be fooled into under-, or overexposing. To provide a degree of manual control, many digital cameras provide exposure compensation known as the EV control. By adjusting the EV control up or down, the camera can be made to increase (or decrease) the exposure by one stop (that is, from 1/125 to 1/160 say). Some cameras provide half-stop adjustments.

To use the EV control, take a picture in the usual way. Compensate for poor exposure by adjusting the EV control up or down and make another exposure. Review using your camera's LCD screen and adjust again as necessary.

6 With just a few simple adjustments, you should end up with a corrected image that looks something like this.

Gamma Correction

1 Adjusting the overall brightness and contrast of an image can work well... or result in the extremes of dark and light being bleached out. If this is the case, the result could be a washed-out and "thin" picture.

2 The solution is to adjust the midtones (aka the "gamma")— the portions of the picture that feature tones falling between the extremes. By singling out these tones, blacks remain black and whites, white, while the intensity of everything else is increased.

3 Launch Paint Shop Pro and open an image you want to edit. Pull down the *Colors* menu and, from the *Adjust* submenu, select *Gamma Correction* (or press *Shift > G*). The gamma correction dialog is displayed.

4 Make sure the *Link* box is checked so that all the hues are affected equally, click and hold one of the sliders, and move it gradually to the right. As you do so, the preview window shows how the image is lightened. An adjustment of no more than about 1.1–1.5 should be enough to improve the picture. Click *OK*.

KEEPING STANDARDS

Gamma is a standard measure of the shift in contrast in an image, though it's usually used to refer to as "midtones."

Table Tops

1 Full control over the tones in an image is provided by the *Histogram* dialog box. Summon the *Histogram* by pulling down the *Colors* menu in Paint Shop Pro (or from the *Image* menu in Photoshop Elements) and selecting *Histogram Adjustment* from the *Histogram Functions* submenu.

2 Daunting, yes, but easy when you know how! First step in brightening an underexposed image is to examine the graph (don't worry, it isn't mathematics!). If the majority of peaks fall to the left of the graph, the image is too dark and must be lightened. If the majority fall to the right, the image is too light. If all the peaks are in the middle and there are few or none to the left and right, the midtones of the image are out of step with the highlights and shadows.

3 Ensure the *Edit* pop-up menu (above the graph window) is showing *Luminosity*, then click and hold the highlights grab-handle (the rightmost triangle beneath the graph) and move it to a point just to the left of the point at which the values fall off. This whitens the white values in the image.

4 Is there a gap between the left edge of the graph window and the point at which the leftmost values begin to rise? This means the deepest shadows are not truly black. Click and hold the shadows grab-handle (the leftmost triangle) and move it just to the right of the point where they rise.

5 Click and hold the *Gamma* grab-handle (the triangle in the middle) and nudge it fractionally to the right. Repeat as required but bear in mind that only very slight changes will be required.

6 If the majority of peaks in the original graph fell at the edges, the midtones can be compressed slightly using the *Midtones* slider at the right of the *Histogram* dialog. Expand the midtones if the majority of peaks fall in the center of the graph. Adjust gradually and preview the image frequently using the *Proof* button. You'll quickly get the hang of it and get good results.

STEP 6—COLOR CASTS

Color photography was once an expensive luxury. Today's digital cameras provide color images that positively sing with vibrant, saturated colors—but they're not always entirely accurate.

Almost invariably, the camera balances color more than adequately and your snapshots are rendered in bright, beautiful colors that bring the pictures to life. But occasionally, and especially in adverse lighting conditions, the camera gets it wrong. If you were committing a picture to film, there'd be little that you could do to rescue it, but digital images lend themselves to extremes of manipulation, and image-editing software provides just the tools necessary for correcting inaccurate color.

Casting Color

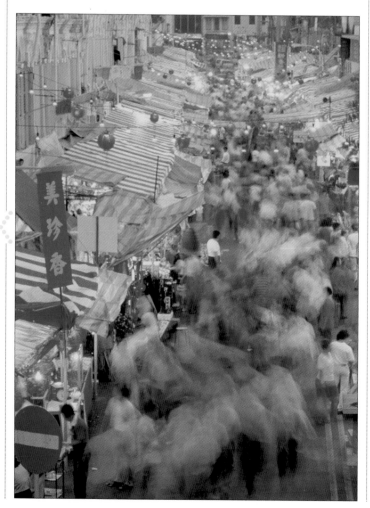

1 Color casts occur principally when you shoot with flash under artificial lighting conditions. The light from tungsten bulbs blends with the flash and tints the picture with an overall yellowish or greenish hue. Similarly, fluorescent lights give a blue tinge to a picture. All good image-editing packages provide automatic color balance controls to correct color casts.

2 Launch your favorite program (here we've used Paint Shop Pro) and open the image you want to correct. Color cast correction works only with 24-bit color images (images that contain 16.7 million colors). If yours is less than this, increase it by selecting *Increase Color Depth* from the *Color* menu.

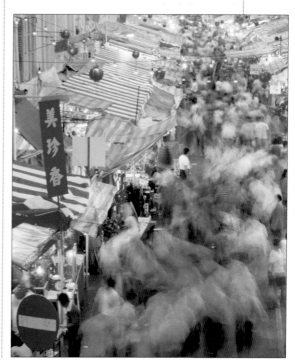

3 Select the *Automatic Color Balance* dialog box by clicking its icon in the *Photo* toolbar (switch this on if it isn't already by selecting *Toolbars* from the *View* menu and then checking the *Photo Toolbar* option). The filter is also available from the *Enhance Photo* submenu under the *Enhance* menu.

4 When the *Automatic Color Balance* dialog is displayed the program immediately changes the image according to the default settings and updates the preview window on the right (move the image around in this window by clicking and dragging).

5 Ensure the *Remove Color Cast* check box is selected (and click it if it isn't). The *Illuminant Temperature* is a measure of the conditions the picture was taken in—outdoors in moderate sunlight, indoors under fluorescent lights, and so on. The default is 65000K, sunlight. Use the slider to select the conditions the picture was snapped. Now click *OK*.

6 The image is automatically color balanced and the cast removed. This filter works exceptionally well at the default settings but badly color cast pictures might need some experimentation. Increase the *Strength* using the slider provided until you arrive at tones that look right.

STEP 7—ALTERING IMAGE SIZE

Conventional photographs are almost always enlargements of the original negatives. Using image-editing software digital photographs can be enlarged (or reduced) too, but just as in conventional photography, there's a small price to pay.

As you now know, digital images contain a finite number of pixels. Enlarge the image significantly and somehow the pixel count must be increased too; otherwise there'd be gaps where the original pixels were pulled apart.

Image-editing packages use a technique known as "interpolation" to increase the pixel count. Sophisticated equations determine the properties of a new pixel based on those around it. Interpolation can be surprisingly accurate over small size increases, but larger increases soon lead to inconsistencies.

Small is Beautiful

But resizing images isn't always about making them bigger—often you'll want to reduce a picture. Images captured with multimegapixel cameras produce huge pictures—far larger than can be comfortably downloaded from the Web for example. A multimegapixel image viewed on screen will be too big to see complete because digital pictures are reproduced pixel for pixel on a screen. For the most part, the Web is geared to work at screen resolutions of 800x600ppi (pixels per inch) and a big image will require sideways scrolling on the part of the recipient! But reducing the pixel count to a value of something less than 600ppi wide will enable the picture to be displayed comfortably.

Digital Enlarging

1 To see the current image size (and other information), click and hold the *Image Information* box in the lower left corner of the Photoshop Elements window or press *Shift > I* in PSP.

2 Resizing an image with either program is easy. In Photoshop Elements, pull down the *Image* menu and from the *Resize* submenu select *Image*.

3 You can resize the image by increasing its pixel count or by specifying a measurement in inches, centimeters, and so on—use the pop-up menus.

Image Size

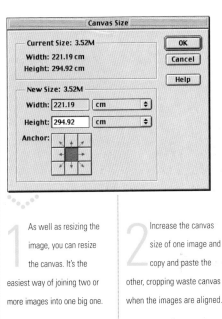

Pixel Dimensions: 1.38M (was 3.52M)

Width: 600 | pixels
Height: 800 | pixels

OK
Cancel
Help
Auto...

Document Size:

Width: 8.33 | cm
Height: 11.11 | cm
Resolution: 72 | pixels/cm

☒ Constrain Proport
☒ Resample Image:

Nearest Neighbor
Bilinear
✓ Bicubic

5 Check the *Resample Image* box, and choose a resampling. *Nearest Neighbor* is a fast algorithm but less accurate than *Bicubic*. However, it produces good results with subject matter that has hard edges. *Bicubic* is better for organic subjects. *Bilinear* falls somewhere between the two. Click *OK*.

6 It's a good idea to Save As (*File > Save As*, or *Shift > Control > S*) so that you have the original to return to if you decide against the resized image.

Canvas Size

Canvas Size

Current Size: 3.52M
Width: 221.19 cm
Height: 294.92 cm

OK
Cancel
Help

New Size: 3.52M
Width: 221.19 | cm
Height: 294.92 | cm
Anchor:

4 Checking the *Constrain Proportions* box ensures that the photograph retains its correct aspect ratio (height to width), and that the image editor recalculates height or width based on your new figure for one or the other. The next thing to do is to resample the image by one of the options in the drop-down menu...

1 As well as resizing the image, you can resize the canvas. It's the easiest way of joining two or more images into one big one.

2 Increase the canvas size of one image and copy and paste the other, cropping waste canvas when the images are aligned.

Reducing

Distorting

Image Size

Pixel Dimensions: 3.52M

Width: 960 | pixels
Height: 1280 | pixels

OK
Cancel
Help
Auto...

Document Size:
Width: 13.33 | cm
Height: 17.78 | cm
Resolution: 72 | pixels/cm

Constrain Proportions
Resample Image: Bicubic

1 Open your image with your chosen image-editing software.

2 From the *Resize* sub-menu under the *Image* menu, select *Image Size*.

3 Ensure the *Constrain Proportions* check box is crossed in the *Image Size* dialog, and type 600 into the *Width* field in the *Pixel Dimensions* section of the dialog.

4 Click *OK* and save the resized picture using *Save As* from the *File* menu. Not only will the physical dimensions of the image have been reduced, so will the file size.

1 And this is what happens if you don't use the auto constrain function... scary!

2 The resized picture is distorted. *Control > Z* returns the image to its former size, and then start again with the *Image Size* dialog. However, in some cases, distortion can add a desirable impact to a picture.

STEP 8—SELECTIVE RETOUCHING

There are two areas in which photographs—conventional or digital—can go wrong: focus and exposure. We've looked at focus earlier in this chapter so now let's turn our attention to the knotty problem of correcting poor exposures…

Correctly exposing a picture can be fraught with difficulties. Difficult lighting conditions, moving subjects, and automatic metering systems can all have an adverse affect on your pictures. Almost all modern cameras have built-in metering systems which work well, but scenes with strongly contrasting elements, overcast or very sunny days, night exposures, and artificial lighting can fool them into poorly exposing a picture. If you make regular use of your camera's LCD preview screen, this shouldn't be a problem—review the picture, and make another exposure using EV compensation and white balance controls to assist the metering.

Filling the Gray Areas

But let's assume you've made several exposures none of which can be repeated, some of which have turned out to be poorly exposed: what can be done? A lot, in fact. Image-editing software can readily rescue pictures which might otherwise be discarded using built-in automatic tools, and those which can be customized to a particular image. Later on in this chapter we'll look at correcting color pictures, but first let's turn our attention to the grayscale image…

Dodge and Burn

1 Photoshop Elements' *Dodge* and *Burn* tools make for excellent selective adjustments to small areas of an image. Both tools work equally well with grayscale and color pictures, but they're especially useful when applied to black and white photographs, which can be tricky to enhance and balance when you're working with the overall image.

2 Select the *Dodge* tool from Photoshop Elements' *Tool* palette. If the *Burn* tool is showing, right-click it and choose the *Dodge* tool from the pop-up pick-list.

3 From the *Options* bar, choose a suitable brush from the pop-up palette—65 works well for small areas, and 300 is excellent for balancing tone over larger areas. Select *Midtones* from the pop-up *Range* palette, and use the slider to enter a value of around 50% into the *Exposure* field.

4 Position the *Dodge* tool over the area you want to lighten, click and hold, then move the tool a little this way and that, until you begin to see the area brighten. Do this a little at a time (i.e., release the mouse button then click and hold again during the process) so that you can use *Control > Z* to go back a step if the dodging appears overly zealous.

STUCK IN THE MIDDLE?

Paint Shop Pro also offers shadows, midtones, and highlights tools to target and correct light and dark areas within an image. Open your picture, and from the *Colors* menu select *High/Midtones/Shadow* from the *Adjust* submenu. To address high, mids, and lows individually, ensure the *Dynamic Adjustment Method* button is selected. *Linear Adjustment* shifts all tones up and down the tonal histogram (see pp. 92–93 for more information about histogram measurements).

5 Experiment with the *Shadows* and *Highlights* settings too from the pop-up *Range* palette until the image is just right. Save As using the *File* menu or by pressing *Shift > Control > S*.

STEP 9—CROPPING

Great pictures rely on strong compositions and creative cropping to emphasize the interesting elements within them. Cropping digital images is easy and fun, and forms the basis of all kinds of interesting special and novelty effects.

A major factor that sets professional pictures apart from those taken by novices is skillful cropping—trimming the unnecessary parts from a picture to draw attention to the area of interest. Indeed there are few if any professional pictures—whether in galleries, newspapers, or magazines—which haven't been cropped. Even an already good picture can be made extra-special by a radical or adventurous crop.

Previously of course, cropping was done at the darkroom stage. As the negative was projected onto photographic paper, the photographer zoomed in on the strongest element letting the rest spill over onto the enlarger's baseboard and be cropped out of the picture.

The Digital Way

Many digital cameras offer cropping facilities built in, and those which don't, of course, can transfer pictures to a computer for editing. But the good photographer should consider the composition first, and you'll learn over time to seek out the main areas of interest and compose the image in the frame.

Elemental Cropping

1 Some pictures demand to be cropped. Here, the interesting part of the picture is all too obvious—you just have to remove the useless material around it!

2 If you're using PSP, open the picture and select the *Crop* tool by clicking on it. The tool is identical in Elements.

3 Move to the picture, click, and drag a rectangle around the part of the picture that you want to keep. When the rectangle encloses the desired part of the picture, release the mouse button.

Cropping in Photoshop Elements

4 If you release the mouse button and find that the rectangle doesn't quite enclose the area you want, click and hold within the rectangle and relocate it. Alternatively, enlarge or reduce it by moving the mouse pointer over a side or corner. Click and drag to enlarge or reduce the image.

5 Double-click within the area of the rectangle. The material outside is discarded and the picture cropped. Press *Control > Z* to undo the crop and have another go.

1 Photoshop Elements offers a similar cropping solution in the form of the its own *Crop* tool...

2 Drag a rectangle (Adobe calls this "bounding box") around the picture selection you want to crop, and Photoshop Elements displays the material which will be removed as an opaque "shield." This is useful in helping you to visualize how the cropped image will appear.

3 What's more, by clicking in the shielded area you can rotate the crop selection bounding box. A right click provides a pop-up "crop or cancel" menu, or you can double-click within the bounding box to crop, much like you can in PSP.

4 You can switch off the crop shield by clicking the appropriate check box in the *Options* bar. If you'd prefer to view the shield as a color, click the *Color* box in the *Options* bar. Select a hue from the *Color Picker* dialog. To change the degree of opacity, use the *Opacity* slider or enter a value in the *Opacity* field on the *Options* bar.

Just for Effect...

1 Save your pictures from inducing sea-sickness in those who see them! Hand in hand with cropping, straightening an image which isn't quite on the level is easy using an image editor such as Photoshop Elements (shown here) or Paint Shop Pro.

2 Pull down the *Image* menu and, from the *Rotate* submenu, select either *Straighten and Crop Image* or *Straighten Image*. If the former would result in the image rotating outside of the window area (and thereby creating an irregular crop), enlarge the canvas (the imaginary area upon which the picture data sits).

3 Open the *Canvas Size* dialog (*Image > Resize > Canvas Size*) and type new values into the *Width* and *Height* fields. Use the *Anchor* locator boxes to determine where the new canvas area will fall.

Super Vignettes

1 By combining cropped images (or crops of the same image in a new canvas) you can create interesting new effects such as this vignette-style image (*opposite*) with ease.

2 Open the picture, choose the *Elliptical Selection* tool (right-click the *Selection* tool and choose *Tool Options* from the resulting pick-list). Draw an ellipse around the picture and press *Control > C* to copy it to the clipboard.

New Image

Image dimensions

Width: 15.000

Height: 15.000

Inches

Resolution: 28.346

Pixels / cm

Image characteristics

Background colour: Black

Image type: 16.7 Million Colours (24 Bit)

Memory Required: 3.3 MBytes

OK Cancel Help

3 Press *Control > N* and create a new canvas with an area large enough for experimenting (and based upon say, three times the area of the original image). Press *Control > E* to paste the clipboard onto the canvas as a new selection.

4 Back at the original, choose the *Freehand* tool to draw a new shape for cropping as shown here. Once again, press *Control > C* to copy the crop to the clipboard.

5 Click on the new canvas to select it and press *Control > E* again to paste in the new clipboard image as a selection. Move the image around to marry up the two to create the desired "keyhole" effect...

6 Select the *Crop* tool to draw around the "keyhole," while leaving in enough of the black background to give the illusion of peeking through a keyhole!

MASKED HELPER

If you're cropping to a particular size, for printing perhaps, or commercial processing, use a cropping mask— essentially, a blank picture of the required size into which you paste the picture, moving here and there until the material you don't want lies outside the mask. A step-by-step guide to making and using a digital mask appears on pp. 114–115.

5

Masterclass Tips

Image-editing software is to a darkroom what a 747 is to a Cessna: both will get you where you want to go, but there's a world of difference in range, speed, and comfort! Combine your digital camera with even entry-level editing software, and you'll have at your fingertips the kind of creative potential that photographers could only dream of previously. In the last chapter we covered a number of editing possibilities that demonstrated the type of tools and filters available to you, and we indulged in some fancy image manipulation. In this chapter—not for nothing entitled "Masterclass Tips"— we'll continue that theme, exploring the more complex options and learning how to make what's in your mind's eye appear on your printer.

LESSON 1—COMBINING IMAGES

Adjustments to your pictures—increasing contrast, tweaking color saturation, and so on—are analogous to similar improvements within conventional photography but the ability to manipulate pixel-based pictures beyond the conventional makes for a world of possibilities.

All image-editing packages offer a range of what can only be described as "special effects"—features for distorting, texturing, combining, and coloring images—and it's these that make digital photography such fun. Improving contrast or enhancing color will make a good photograph of an otherwise ordinary one. Special-effects features—such as combining several pictures into one, mirroring, distorting, adding grain, feathering for highlighting and shadows, or the really wild special effects such as transforming your pin-sharp digital image into something resembling a watercolor or an impressionist painting—can really stretch your imagination to the the limit!

Don't Overdo It

It's fair to say that many of the more outrageous special effects can become tiring, and it's often difficult to see where you might use some of them (but kids love playing with special effects!). However, it's when manipulating pictures that might otherwise be discarded that digital photography and image-editing software come into their own. And even as a beginner, you'll find that creating amazing effects is easy with a bit of practice...

Make Do and Mend

1 Here's an example of the kind of manipulation that makes image-editing software such a powerful tool—even for beginners. This picture of rolling fields of hay is spoiled by a nondescript gray sky. A fix is just a click, cut, and paste away...

2 Launch your image editor and open the picture you want to correct. Select another picture that features an attractive sky. Using the *Marquee* tool, draw around a selection of sky and press *Control > C* to copy it to the clipboard.

3 Open the original image and paste the recently copied sky onto it. Here we've used Photoshop Elements and have called this Layer 1.

5 Next make the new sky layer visible and active. Invert the selected area and delete. The new sky now follows the horizon line of the fields and your new composite image is complete.

6 The finished picture. There's much more that can be done, but with even just a simple cut and paste from another picture we've improved this one enormously. As you work through the more advanced examples, you'll begin to see the possibilities for manipulating your own pictures and developing your skills along the way.

4 Now make just the original image layer visible and active. Using *Magic wand* tool, with appropriate tolerance (95 is used here) select just the sky area.

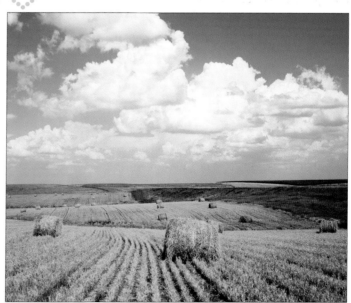

LESSON 2—DISTORTING IMAGES

Distortion techniques have long been used by professional photographers to heighten the impact of a picture. The ability to distort digital images easily opens an incredible palette of creative effects that will enable you to go far beyond the simple family snapshot…

Anyone familiar with the music of the Beatles will be aware of the photograph of the band used on the cover of the "Rubber Soul" album. The photographer produced a distorted, rubbery image by projecting a transparency of the image at an angle and reshooting it. The effect was and is startling: eye-catching certainly, but with an underlying tension that is at once unsettling and compelling.

If you've experimented with wide-angle lenses or a wide-angle setting on your digital camera's zoom lens, you'll have noticed that features become exaggerated or diminished depending on where the camera is in relation to the subject, and shooting tall buildings causes them to "lean" in relation to each other (the effect is known as "converging verticals").

Don't Look Now

Whether caused by the lens or manipulation of the picture once it's transferred to the computer, distortion can have a dramatic effect—even slight distortion is in some way unsettling because it makes us look at the world in a way that is different from reality. However, as with all visual effects, remember this works better on some photographs than on others.

In a Spin

1 Photoshop Elements is particularly well endowed with distortion filters (more are available as third-party plug-ins), and some of them are truly spectacular!

2 Try this: open a picture in Photoshop Elements—one that features a tall subject will work especially well.

3 Pull down the *Filters* menu and select *Polar Coordinates* from the *Distort* submenu. When the *Polar Coordinates* dialog is displayed click the *Rectangular to Polar* button then click OK.

4 Now soften the edges of the join. Select the *Blur* tool from the tool palette. Pop up the *Brush* menu on the *Options* bar, and select Brush 46 (or a similarly loosely defined brush). Set the *Brush Pressure* value at 60%. Click and rub the *Blur* tool over the sharply defined edges of the image.

5 All that remains is to crop the background that no longer contains picture data, and then save the results.

Hall of Mirrors

1 Create your own version of the "Rubber Soul" record cover. Open an image (a group portrait works well) in Photoshop Elements. Summon the *Shear* dialog (*Filters > Distort > Shear*). Click and move the line in the distort grid at the top left of the dialog. The image is distorted along the curves you specify.

2 Using the *Pinch* distortion filter (*Filters> Distort > Pinch*) you can distort an image so that its centre is "pushed" or "pulled" toward the viewer.

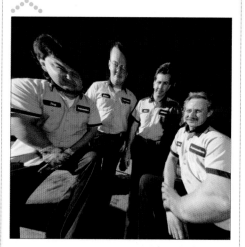

3 Get the fish-eye lens effect with the *Spherize* filter (Elements: *Filters > Distort > Shear*). Use the slider to determine whether distortion will be concave or convex, vertical, horizontal, or spherical. Crop the image to further emphasize the effect.

DISTORTION DOCTOR

Distortion is an eye-catching effect, but there may be an occasion when you'd prefer to go the other way: to straighten an image that has unintentional distortion generated by the camera's lens. Andromeda Software offers a Photoshop plug-in to do just that. LensDoc is an easy-to-use utility for image-editing software that can make use of Photoshop plug-ins. A demo is available for download at *www.andromeda.com*.

LESSON 3—ADDING TEXTURE

Not content with the visual impact of your pictures? Spice them up by adding a sprinkling of texture. Known as "noise," it is the equivalent of creating a grainy conventional picture. Very atmospheric, particularly with black and white images.

Previously we examined the issue of digital noise—speckles of color that invade, and can blight, an otherwise attractive picture by appearing randomly throughout. These speckles can be removed quite easily using the ready-made tools provided by most image-editing packages. We tried one or two of them, such as the *Edge Preserving Smooth* and *Despeckle* tools in Paint Shop Pro earlier in this chapter, and there are others which we'll look at elsewhere on these pages. Those packages that don't sport noise-reduction filters can be used manually to remove noise (but the task can be onerous).

Not All Noise Annoys

Paradoxically, you might actually want to add noise! Contrary to normal intuition, inserting speckles where none existed previously isn't necessarily a quick route to a spoiled picture. A noisy image can simply be a grainy one which, given the right subject matter and tonal value—a gritty black and white street scene perhaps—is enhanced by the "realism" that noise brings. First though, let's look at one or two further options for removing noise…

Gritbusters #1

1 Although more usually associated with color images, noise can affect black and white pictures too. Paint Shop Pro provides several tools that work with both color and black and white pictures, but especially well with the latter. Launch PSP and open your image.

2 Pull down the *Effects* menu and, from the *Noise* submenu, select the *Median* filter. Although it is intended for use on small selections that are markedly different from the overall picture, the *Median* filter also works well when applied to an entire image if you use it sparingly.

3 The default for the filter aperture is about 30 pixels depending on the image (the number of pixels that are averaged and then deintensified). Over an entire image, this will produce an attractive effect —but conversely a great deal of detail is lost.

4 Instead, type in a value of about 5 pixels and click OK. Much of the grain is removed and a little of the fine detail. Now apply the *Unsharp Mask* and the noise has all but gone.

Gritbusters #2

1 PSP's *Salt and Pepper* filter (*Effects menu> Noise> Salt and Pepper*) works especially well with grayscale images. By determining when a light or dark speckle in a picture differs substantially from its neighbors, the speckle can be removed.

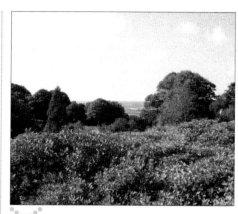

2 Fine detail is easily lost using *Salt and Pepper* so select smaller areas of the picture—those without fine detail—and apply the filter. Experiment with speckle size and sensitivity until you balance the loss of detail with the removal of speckles.

3 Afterward, use the *Sharpen More* and *Clarify* filters to add contrast and sharpness to the overall image. But don't overuse the *Sharpen More* filter.

4 Unlike the *Salt and Pepper* and *Median* filters, *Texture Preserving Smooth* (*Effects menu> Noise*) attempts to retain detail while ridding an image of speckles. It does this by gauging and comparing "textured" areas and working selectively.

5 Once again, experiment by entering different values into the *Amount of correction* field and gauging the trade-off between retaining detail and losing noise.

True Grit

1 Adding noise to an image—particularly a black and white picture—can give it a "period" feel. A street scene perhaps, or a railroadstation will respond well to a grayscale and grain treatment.

2 Of course, there's no need to start out with a black and white picture. If the image you want to manipulate is in color, begin by discarding the color data. Here, PSP's *Grayscale* filter can be applied (*Color menu> Grayscale*).

3 From the *Effects* menu, select *Add* from the *Noise* submenu. You can experiment with the percentage of noise to add—about 10% is a good starting point. Click the *Uniform* button to select it.

4 What was at first a pretty, but dull picture of a main street is transformed into a period piece that harks back to a bygone era.

LESSON 4—MOTION EFFECTS

You don't always want your pictures to appear razor sharp. Add a bit of dynamism by using creative blurring techniques (and especially adapted filters) to give the illusion of motion to your pictures.

Earlier, we looked at correcting out-of-focus, fuzzy images—the result of camera movement, low light, or a moving subject—by applying various software filters, but there are times, strangely, when you might actually want to blur an image rather than sharpen it. Creative use of blurring can be used to give an impression of speed and a degree of "movement" to your pictures—a shot of a moving car or motorcycle, for example. Photographers using conventional equipment pan the camera—that is, move it in time with the moving subject—while using a slowish shutter speed.

Panning

Panning has the effect of keeping the subject in focus while blurring the background, thereby recreating the sense of speedy movement. Digital photographers can pan by moving their cameras too, but it isn't an easy technique to master. However, there's another way to get more or less the same effect which is fun and requires little effort!

Panning Motion

1 Conventional panning is easy to try, but difficult to master, so let's cheat to get the same effect using image-editing software. First open your preferred software—here we've used Photoshop Elements—then load a suitable picture, in this case, a BMX cyclist.

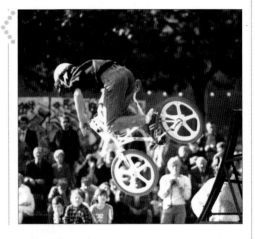

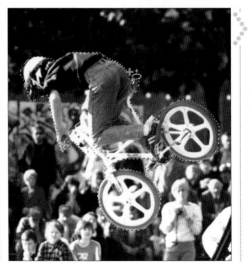

2 Carefully draw around the cyclist with the *Freehand* tool, then copy it to the clipboard by pulling down the *Edit* menu and selecting *Copy* (or simply pressing *Control > C*).

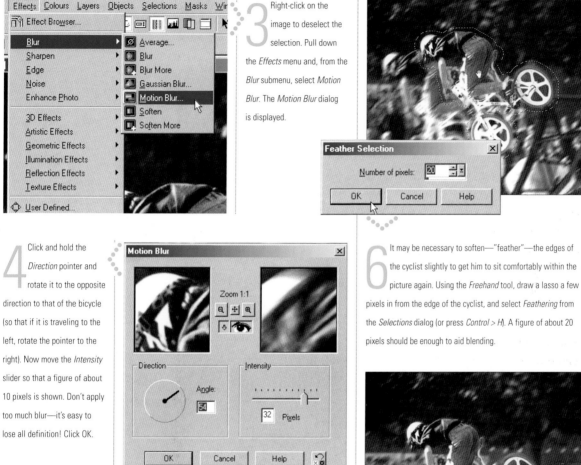

3 Right-click on the image to deselect the selection. Pull down the *Effects* menu and, from the *Blur* submenu, select *Motion Blur*. The *Motion Blur* dialog is displayed.

4 Click and hold the *Direction* pointer and rotate it to the opposite direction to that of the bicycle (so that if it is traveling to the left, rotate the pointer to the right). Now move the *Intensity* slider so that a figure of about 10 pixels is shown. Don't apply too much blur—it's easy to lose all definition! Click OK.

5 Back at the now blurred picture, press *Control > E* to paste the copied image of the cyclist back into the picture as a selection. Take care to position it exactly over the existing, but blurred cyclist—instant panning!

6 It may be necessary to soften—"feather"—the edges of the cyclist slightly to get him to sit comfortably within the picture again. Using the *Freehand* tool, draw a lasso a few pixels in from the edge of the cyclist, and select *Feathering* from the *Selections* dialog (or press *Control > H*). A figure of about 20 pixels should be enough to aid blending.

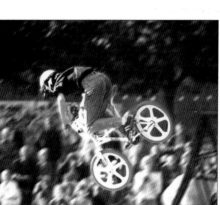

7 The finished picture replicates remarkably accurately the effect achieved when panning in a more conventional way. The cyclist is frozen in action, while the spectators in the background are blurred, giving the impression of camera movement.

LESSON 5—VIGNETTES

Have fun transforming your nearest and dearest into living antiques using sepia tones, and some creative cropping and feathering techniques. These make up an instant aging process that is fun to try and attractive to display to others.

Many cameras provide a range of effects that can be applied before the images even leave the camera for the relative safety of your computer. A perennial favorite is sepia toning, which makes an instant antique of virtually any photograph. The technique is best applied to portraits and is especially good when combined with other effects such as "feathering"—cropping and softening the edges of a picture—from within an image editor.

If your camera provides sepia toning "at source" then by all means apply it and save yourself the trouble when the picture is imported into the image software (though it might be that toning from the software provides a better result—experiment!).

If the camera doesn't offer the effect, follow the steps outlined here to create living antiques of your friends and relatives—they'll be delighted!

Ten Steps to Tone

1 Select a suitable image. While almost any picture can be artfully cropped and sepia-toned, a portrait works best—head and shoulders or full length with one or more subjects.

2 Launch your favorite image-editing software (here Photoshop Elements) and open the picture.

Begin by discarding existing color information. Pull down the *Enhance* menu and, from the *Color* submenu, select *Remove Color* (or press *Shift > Control > U*). The picture is rendered in black and white.

Artful cropping enhances the ultimate "aged" effect. Select the *Elliptical Marquee* tool by clicking on it. The tool defaults to the *Rectangular Marquee* tool. If yours is rectangular, click on it and hold until the pop-up selector appears, and then choose the *Elliptical* tool.

Draw an ellipse over the image by clicking, holding, and dragging. If it isn't positioned quite right once you've drawn the ellipse, click on it and move it until it's just right.

Press *Shift > Control > I* to select the background (that is, to switch from the selected portion to the previously unselected portion of the picture—all will become clear in a moment). Pull down the *Select* menu and choose *Feather* (or press *Alt > Control > D*).

Back at the picture, press delete. As if by magic, the background material is removed leaving the subject matter with a feathered edge.

Apply the sepia tone by selecting the appropriate filter from the drop-down *Filter* tab.

The finished result, looking for all the world like it came direct from Kodak No.1, circa 1900!

LESSON 6—ADDING EFFECTS

Many image-editing programs provide a number of interesting and fun texture effects to apply to your pictures. Some of the texture filters are extremely effective while others are… well, clichéd at best. But all are fun to play with and, used sparingly, can enhance an otherwise dull picture.

Texture effects really come into their own when used to create greetings cards, T-shirts, and the like—a novelty finish is just the thing to grab the attention! How best to use the texture and similar special effects? Experiment! Control-Z will undo any effect, or you can simply abandon the picture without saving or "Save As" to make a copy. Only by playing with the effects provided by your image-editing software will you envisage what can be done and where best each can be applied. Only a few pictures lend themselves to this kind of treatment, but the results when they do can be startling!

(*Below*) The same image again, but this time after having PSP's *Colored Chalk* effect applied (*Detail* 50, *Opacity* 96). A similar effect, but with even more texture.

Paint Shop Pro's *Black Pencil* effect (*Effects menu> Artistic Effects> Black Pencil*) adds a kind of stippling effect to this grayscale vignette of a steam engine and carriages. The picture is transformed into a lineside, sketchpad drawing.

(*Left*) Instant artist! PSP's *Brush Strokes* effect transforms a digital picture into a work of—traditional— art. Experiment with the length and density of the strokes, the width, opacity, and number of bristles in the "paint brush."

(*Left*) Photoshop Elements' *Liquify* filter can be used to create all kinds of interesting effects. Set the *Brush* size to a low value say, 10, and you can tinker gently with straight edges in a picture to soften them. A large brush of say, 130, combined with a pressure of about 15 or 20, will completely transform an image!

(*Above*) Much the same texture using Photoshop Elements' *Brush Strokes* effects. Elements offers a wide selection of painted effects including the watercolor shown here.

Masterclass Tips

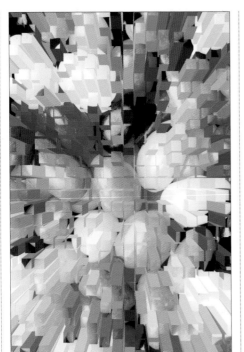

(*Left*) Ocean Ripple (*Filter> Distort> Ocean Ripple*) makes an image appear as if it's being viewed through a piece of frosted glass. Color pictures respond exceptionally well to this effect. The distinction between colors is blurred, but their intensity is enhanced. Elements also provides a distortion filter called *Glass* (*Filter> Distort> Glass*) which has a similar, but more intense result.

(*Above*) Extrude is a very popular effect that can be seen in advertisements, magazines, flyers, and the like. Photoshop Elements makes recreating the effect easy. Open your picture, pull down the *Filter* menu, and select *Extrude* from the *Stylize* submenu.

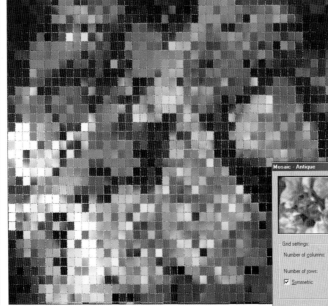

This mosaic effect is marvelous for creating "robot vision" (think: kids' birthday cards!). Use it with brightly colored abstract images such as a close-up of a selection of fruit for a vista of hues.

And here's yet another way to recreate the illusion of motion within a static image. The *Wind* filter (*Filter> Stylize> **Wind***) slides pixels left or right to give the effect of a strong gust of wind! You choose between *Wind, Blast,* or *Stagger*!

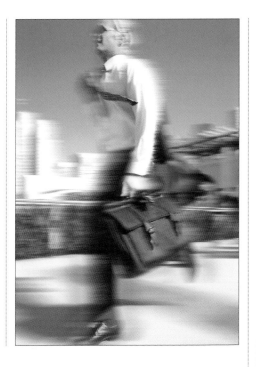

IN EFFECT...

Photoshop Elements' Texturizer function offers a range of effects, but you can expand on these by acquiring third-party "plug-in" effects packages.

1 Use your favorite Web search engine to locate plug-in Photoshop Texture effects. Try searching on "PhotoShop" and "texture" (in this way: +photoshop+texture or "photoshop texture").

2 Select from those on offer and download them to your computer.

3 From the *Texturizer* dialog, access the pop-up *Texture* menu and select the *Load Texture* option. Navigate to the downloaded textures using the file browser.

4 Apply the new textures by choosing them from the pop-up *Texture* menu in the usual way.

Or for the ultimate in textured canvas effects, summon Elements' *Texturizer* dialog (*Filter> Texture> **Texturizer***) and select from brick, burlap, sandstone, and so on. Use the *Scaling* and *Relief* sliders to determine the size and depth of texture.

LESSON 7—CREATING PANORAMAS

See the world in 360 degrees using photomontage techniques—this impressive effect combines lots of individual pictures into a single uninterrupted image that spans an entire horizon.

In the 1950s and 60s a number of imported cameras became available which would take a panoramic photograph spanning more or less everything from left to everything right in front of the photographer. These were used quite seriously to capture images of large groups of subjects such as parades of soldiers, engines, and carriages—even wedding pictures! The panoramic camera featured a swivelling slitted lens housing which turned through 180 degrees. The slit admitted light a slice at a time to reach and expose the film within.

By Hand

Many photographers copied the technique using ordinary cameras. By standing in one spot, taking a picture, turning to the left or right slightly, taking another picture and so on, the resulting prints can be cut up and stitched together to make one long photograph.

As a digital photographer you have the means to produce truly incredible panoramas and photomontages. Some cameras actually enable you to create a composite image at source using software within the camera itself. But even if yours doesn't stitch together images using editing software is easy. Some image editors (notably Photoshop Elements) provide specialist tools for panoramic shots.

Stitch Up

1 Let's assume your camera doesn't provide for panoramic shots, and your image-editing software is of the plain-vanilla type. The first step is to take the pictures that will become the panorama. This is best done with the aid of a tripod or other steady rest to ensure that all the images are taken at the same height (though even then corrections can be made digitally). Allow plenty of overlap between each image and try to keep the same distance from the subject to preserve the perspective over what will become the composite panorama. Launch your software and browse the images.

2 Select what will be the first in the sequence and open it (here with PSP). Ensure the picture is selected and press Shift-I to summon the image information dialog. Make a note of the picture's dimensions. Repeat for each image that will be featured in the montage.

3 Press *Control > N* and create a new picture box based on the collective dimensions of the pictures for the montage. Give yourself plenty of elbow room—you can crop neatly when the images are in place.

New Image

Image dimensions:
Width: 32767 Pixels
Height: 1100
Resolution: 28.346 Pixels / cm

Image characteristics:
Background colour: Black
Image type: 16.7 Million Colours (24 Bit)
Memory Required: 103.1 MBytes

OK Cancel Help

4 Select the first in the sequence. If you want to use the entire picture, press *Control > C* to copy it to the clipboard, otherwise make a selection using the *Selection* tool and copy the selection to the

6 Often what gives the stitch-up game away is the different tonal qualities of one "frame" to the next, caused by the time delay (and therefore potentially the light quality) between each shot. Adjust and match the brightness of the individual images by opening and adjusting their histograms.

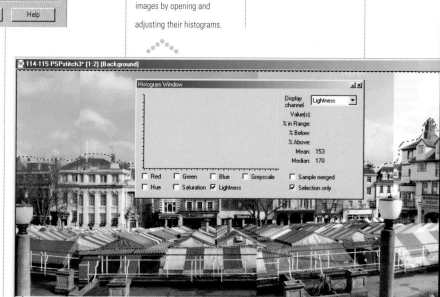

5 Select the empty picture box and press *Control > E* to paste in the contents of the clipboard as a new selection. Repeat for each image, carefully aligning as you go.

7 Although the new image is complete, the joins are hardly seamless! Select the *Clone* tool, right-click a "clone source" near enough to the first join, but not so close that the cloning effect becomes obvious. Crop to suit and save.

Masterclass

Painless Panoramas

1 If your image-editing software provides the necessary tools to stitch together separate images, the task will be easier still! Here is Photoshop Elements...

2 As before, ensure your sequence is taken on a tripod in light that is not subject to wild changes (i.e. nice, blue sky and no clouds to create unwanted shadows). Maintain perspective where possible by staying at a uniform distance from the chosen subject.

3 Open the *Photomerge* dialog from the *File* menu and click the *Add* button. A file browser will be displayed. Navigate to the folder that contains your images. Shift-click over the range of pictures and click *Open*.

4 Elements' *Photomerge* will make an excellent attempt at automatically merging the images into one panoramic picture, or you can choose to position them manually before the program smoothes away the obvious edges. Click the *Attempt to Automatically Arrange Source Images* check box. Check the *Apply Perspective* box and type a figure of, say, 50%, into the *Image Size Reduction* field (otherwise the resulting composite will become unwieldy). Click OK.

5 Elements now takes over, opening, positioning and adapting the sequence of pictures to make a single image. Sit back and watch the fireworks!

6 When the composite is created, the *Photomerge* screen is displayed. The *Preview* window shows the image as it will look before cropping. Use the *Navigator* window to move around the preview image by clicking and moving the red rectangle within the *Navigator* window (the slider beneath this zooms in and out of the preview).

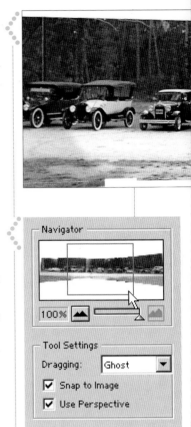

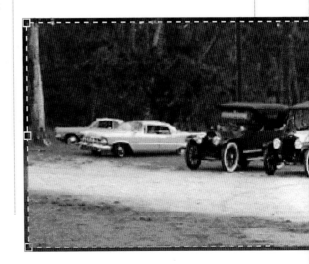

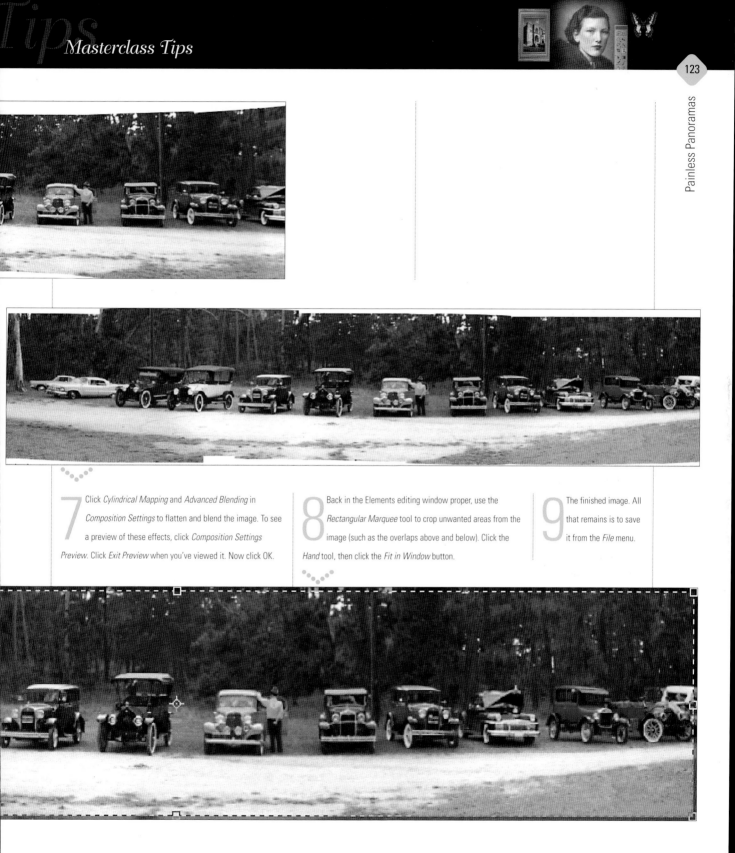

7 Click *Cylindrical Mapping* and *Advanced Blending* in *Composition Settings* to flatten and blend the image. To see a preview of these effects, click *Composition Settings Preview*. Click *Exit Preview* when you've viewed it. Now click OK.

8 Back in the Elements editing window proper, use the *Rectangular Marquee* tool to crop unwanted areas from the image (such as the overlaps above and below). Click the *Hand* tool, then click the *Fit in Window* button.

9 The finished image. All that remains is to save it from the *File* menu.

LESSON 8—CREATING SOFT FOCUS

A blurred image isn't necessarily a bad one if the blurring is used selectively to create a "softer" atmosphere. The technique is used by photographers all the time and it's one that lends itself perfectly to being replicated in the digital darkroom!

The camera never lies is an old saying that rings only partly true. Certainly what the camera's lens sees is what the camera captures on film or digital storage card, but there are many tricks and techniques which can ensure that what the end-viewer sees is something markedly different to what was snapped. Of course, these techniques are not intended in any way to fool those who see the picture, they're used to enhance it.

Premeditated or Not

To achieve a soft-focus effect, conventional photographers use various filters fitted to their lenses which help to diffuse the light and create a softer, slightly misty atmosphere without throwing the subject out of focus. Of course to achieve this effect the conventional photographer must decide in advance whether to use a soft focus filter or not. Not so the digital photographer, with basic image-editing software the same effect can be achieved in a matter of moments, and applied to any image that is suitable.

Sharp and Sweet

1 Only after taking this picture did it become clear that the subject's light coloring would lend itself well to a soft focus effect. It really is easy to achieve.

MOVING TARGET

Soft focus and blurring can also be used effectively to create the illusion of movement. One way to achieve this is known as panning—a technique which can also be synthesized in the digital darkroom. Turn to pp. 112–113 for details of how to do it.

Creating Soft Focus

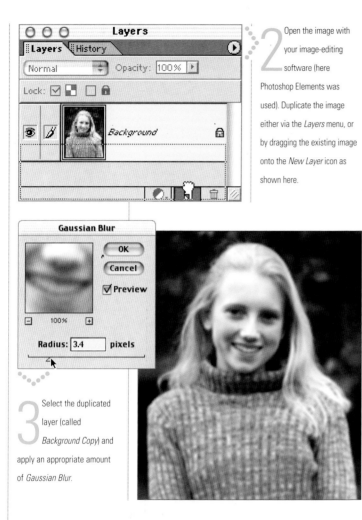

2 Open the image with your image-editing software (here Photoshop Elements was used). Duplicate the image either via the *Layers* menu, or by dragging the existing image onto the *New Layer* icon as shown here.

3 Select the duplicated layer (called *Background Copy*) and apply an appropriate amount of *Gaussian Blur*.

FIELD STUDIES

Depth of field (aka "depth of focus") is the portion of a picture between the foreground and farthermost point at which the image is in focus. Lenses of different focal lengths offer different depths of field. Combined with aperture, it's easy to isolate a focal point. That's why a moderately long lens of, say, 85mm to 135mm is ideal for portraiture. The depth of field is compressed, flattening features and enabling a strong focal point to enhance the subject.

4 The next step is to *Lighten* the background copy, accessed via the *Layers* menu. This will allow the original background layer to show through.

5 Finally position the background copy layer over the original layer, and the blurred but slightly opaque copy of the original layer will create a the diffuse effect of the conventional soft-focus filter.

LESSON 9—ALTERING BACKDROPS

Build incredible pictures by combining separate images—one on top of the other—in a kind of layered sandwich, editing each until they appear exactly how you want them, and then merging for a final effect that can't be equalled using a single image.

Working with layers is the great secret of master image manipulators and the frosting on the cake of the best image-editing software such as Adobe Photoshop, Photoshop Elements, and JASC's Paint Shop Pro.

That power lies in the ability layers give you to construct a composite image by combining pictures, one on top the other, each of which can be edited individually without in any way affecting the other layers. In this way it's possible to enhance everyday pictures beyond measure, and create fantastic special effects and convincing montages and panoramas.

Mix and Match

You can rotate layers, color, and render them transparent, link one or more together to apply an effect across several layers, and import and delete them. Image editors that support layers generally provide a palette of some sort so that you can see at a glance the layers that make up an image along with their attributes. When you're satisfied that the picture is how you want it, you can compress all the layers into one to reduce the size of the file, but without compromising quality. So now let's explore a fun example of using layers...

Spirit of Fun

1 There are many famous—but faked— photographs of people in incongruous settings. But whereas in the "good old days" of conventional photography, photographers had to go to painstaking lengths to achieve barely believable results, in the wonderful world of digital imaging, it is now possible to travel just about anywhere in the world. You, your family, and your friends could be sunning themselves in the Caribbean in next to no time. It's easy to source some vacation destinations—spend just two minutes on the Web and you'll find you have countless, albeit low-res, exotic paradises to choose from.

2 Select a suitable image of the people that you want to send on a dream holiday of a lifetime.

3 Using the *Freehand* tool, carefully draw around the figures. It is worth spending time doing this, as the more accurately you draw around them the more realistic the effect. Select *Copy* from the *Edit* menu (or press *Command > C*)

4 Select the Background image and paste in the image from the clipboard as a new layer. Pull down the *Edit* menu and, from the *Paste* submenu, select *As New Layer* (or press *Control > L*). The second layer appears over the top of the first layer.

5 Click the *Toggle Layer Palette* button on the *Standard* toolbar to display the *Layer Palette*. Now you can use the various image-editing tools to ensure the tones and colors are balanced.

6 At any time you can select and reposition the top layer by clicking on it. When the picture appears as you want it, flatten the layers in the image by selecting *Merge All* from the *Merge* submenu on the Layers menu and *Save As* from the *File* menu.

ELEMENTARY LA

Photoshop Elements provides an on-line layers tutorial and a selection of pictures that you can use as you work through the examples—by far, the best way to learn how to use layers.

LESSON 10—ADDING WORDS

A picture, so the old saying goes, is worth a thousand words, and while it's certainly true, there are times, believe it or not, when a line or two of text can make all the difference to your pictures.

By now you're probably tiring of us extolling the virtues of the digital over the conventional. It's true that photographs from film are often higher quality (in terms of resolution and color rendition) than their digitized counterparts and that digital photography is still relatively expensive, even considering the lack of processing. But digital photography is so supremely flexible and the pictures accessible—no darkroom, no chemicals, and complete mastery over the images, as you know so well by now. And one more truly useful advantage in the digital world is the ability to add text to your pictures, and not just plain text either!

Say it in Words

Combining text and images presents some marvelous opportunities to create greetings cards, flyers and handbills for club events, church fairs and the like, documents in support of your business or simply to enhance the image and give it a new twist!

There are many ways to add words, as a simple line of text that is a caption to the picture, as a separate and fancy greeting or slogan, or as part of the picture itself, the letters embossed or stencil-cut from the subject matter of the image.

Words and Pictures

1 At its simplest level, adding a line of text to a picture is easy using image-editing software, though it's rarely possible simply to type text on top of the picture as you do when you enter text into a word-processor document. Instead, position a cursor on the picture, summon a text dialog, and enter the text into that cursor position afterward. Photoshop Elements is one of the few packages that enables you to type text into pictures as effortlessly as if you were typing in a word processor. First, launch Photoshop Elements and open the selected picture.

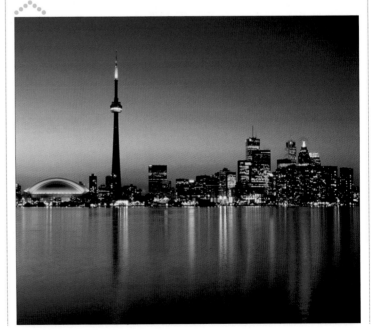

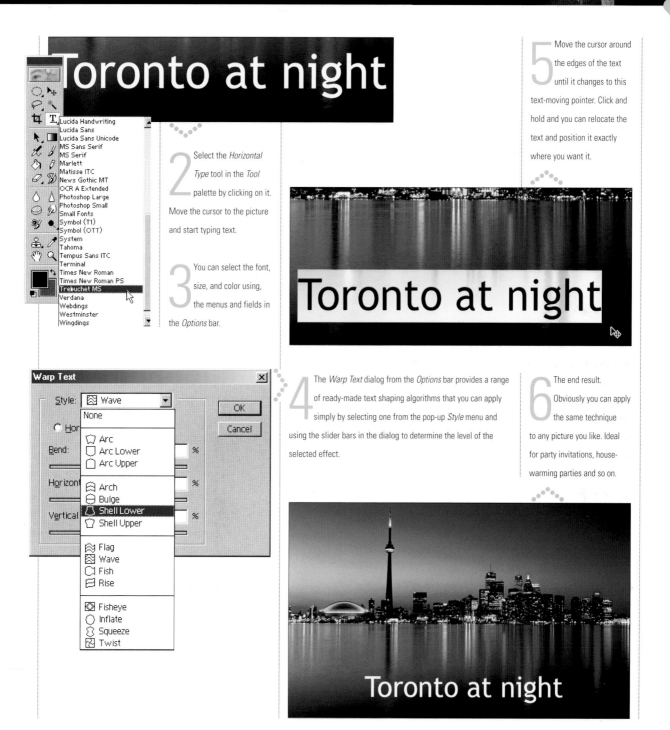

5 Move the cursor around the edges of the text until it changes to this text-moving pointer. Click and hold and you can relocate the text and position it exactly where you want it.

2 Select the *Horizontal Type* tool in the *Tool* palette by clicking on it. Move the cursor to the picture and start typing text.

3 You can select the font, size, and color using, the menus and fields in the *Options* bar.

4 The *Warp Text* dialog from the *Options* bar provides a range of ready-made text shaping algorithms that you can apply simply by selecting one from the pop-up *Style* menu and using the slider bars in the dialog to determine the level of the selected effect.

6 The end result. Obviously you can apply the same technique to any picture you like. Ideal for party invitations, house-warming parties and so on.

Shadow World

1 A drop shadow is a darker version of the text which sits behind and slightly to one side of the foreground text, making the background type, in effect, a shadow. Drop shadows can be seen everywhere in newspapers and magazines and they look particularly good when applied to photographs. Fortunately, they're also easy to make!

2 Launch your chosen image editor (here Photoshop Elements) and open a suitable picture.

3 Click on the *Horizontal Type* tool to select it. Ensure the *Create a Text Layer* button is selected.

4 Choose a font and size from the drop-down menus on the *Options* bar.

5 Click to position the cursor where you want to type the text (you can move it later) and start typing. Use the text moving pointer to locate the text exactly where you want it. This will become the shadow.

Set the text color

6 Click another cursor into place and type the same line of text again. Click on the text color square on the *Options* bar and choose a contrasting color for the foreground text. Use the text moving pointer to locate this new line of text over the first line but make it slightly askew so that both can be seen—the background text becomes a shadow to the foreground text.

7 Flatten the layers by selecting *Merge Visible* from the *Layers* menu (or press Shift-Control-E). To save, select *Save As* from the *File* menu.

8 You can choose any color combinations for the text and its shadow, though some, especially contrasting colors, primary colors with black, or gray and black work very well.

LESSON 11—FRAMING

Surround your shots with an attractive border and you'll strengthen the contents within. Some cameras provide built-in border functions, and you can create and apply them in image-editing software too...

The popularity of borders—the edges which frame a picture—waxes and wanes according to changes in taste. Once, all photographs sported a white border a few millimeters wide. The border is actually an unexposed area of the photographic paper on which the print is created. In the 1970s, the vogue for borderless prints was all-pervading. Today, both are available but borderless prints are probably slightly more popular than the bordered variety.

What's often missed in the bid for greater image area is that far from taking something away from a picture, a border can strengthen the composition and provide a reference point against which the picture is balanced.

Many digital cameras offer a number of frames that you can apply to a picture before it's downloaded to your computer, and of course, adding all kinds of plain and fancy frames is easy once your picture has been opened within image-editing software.

If the borders provided with your image-editing software, don't fit the bill, Extensis PhotoFrame, a third-party plug-in, has plenty on offer.

Bordering Beauty

1 Paint Shop Pro and many other image editors offer picture framing functions. Start by launching your software (here PSP) and open a picture.

2 Pull down the *Image* menu and select *Picture Frame*. The *Picture Frame* dialog is displayed.

ON-BOARD BORDER

If your camera offers a selection of built-in frames, you usually apply them by selecting one before taking the picture. Flick through the frames on offer, choose one, and size and position it using the LCD preview screen, then take your picture. Often it's possible to download more frames to your camera from third-party suppliers or even design and download your own. Refer to your camera's directions for details. The disadvantage of using built-in frames is that they become part of your picture—you can only remove it by cropping using image-editing software.

3 Select available frames using the pop-up pick list at the left of the dialog. To apply frames your image must be grayscale or 24-bit color. Increase to the required color depth using the *Increase Color Depth* option from the *Colors* menu.

4 Elect to apply the frame within the existing picture area or outside it. The program automatically increases the canvas size.

5 Click OK and the border is applied. As ever, press *Control > Z* if you decide the border isn't right for the picture.

LESSON 12—COLORING

Color photography has long been available and all digital cameras take saturated images that are nothing short of lavish in their rendition of colors, yet hand-coloring a black and white image can make for a striking picture, and the process is easy using image-editing software.

There are two kinds of hand coloring. The first involves your taking a black and white photograph and adding artificial color. The other type of colorizing might better be described as hand "uncoloring" and we'll show you that technique over the page.

A hand-colored photograph has an esthetic—and perhaps even artistic—value beyond that of the picture alone.

The mechanics of colorizing are made exponentially easier using a computer and a digital image, but getting good results continues to be a fine art (in every sense)

though much of the fun lies in the execution. You can color old black and white photographs you've copied with your digital camera or grabbed with a scanner, grayscale digital pictures you've taken yourself, or even a color picture from which you've discarded the color information!

Decolorizing—taking the color out of an image leaving only a small colored portion—is easier, but can add a great deal of impact to a picture. The effect is often used on advertising billboards and the like precisely because it is so eye-catching.

Adding

1 Select a picture you want to hand color and open it with your chosen image-editing software, (or open a color image and remove the color information rendering the picture as a grayscale image).

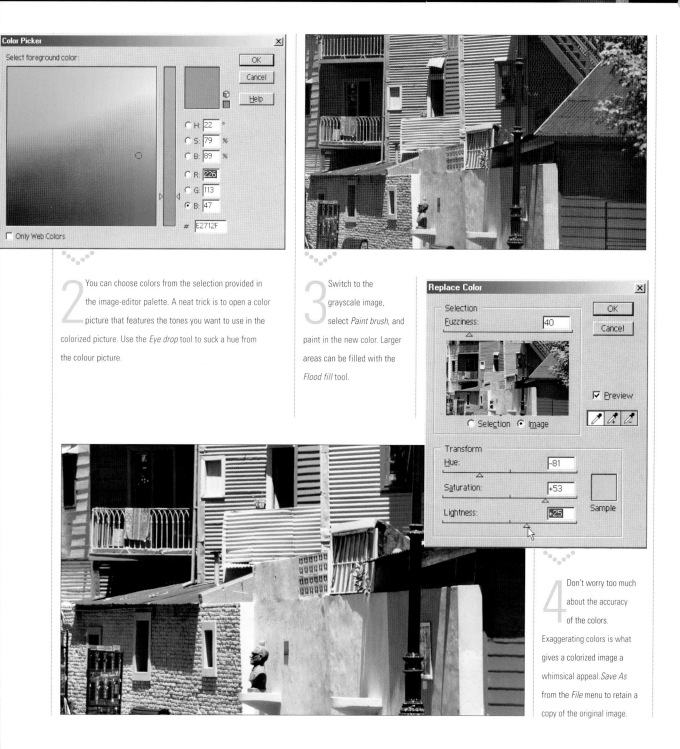

2 You can choose colors from the selection provided in the image-editor palette. A neat trick is to open a color picture that features the tones you want to use in the colorized picture. Use the *Eye drop* tool to suck a hue from the colour picture.

3 Switch to the grayscale image, select *Paint brush*, and paint in the new color. Larger areas can be filled with the *Flood fill* tool.

4 Don't worry too much about the accuracy of the colors. Exaggerating colors is what gives a colorized image a whimsical appeal. *Save As* from the *File* menu to retain a copy of the original image.

Subtracting

1 Decolorizing an image (i.e., discarding all color information except one part of the picture) can be done in several ways. Those who've read through Chapter 5 and now know how to manipulate layers can work with two copies of the same image, one grayscale, one color, throwing away all but the small color element in one, and flattening the two layers so that they merge into a decolorized image. However, there are far easier ways to get more or less the same effect. Try this...

2 Launch your image-editor (here Adobe Elements) and open the picture you want to decolorize.

3 Select the *Lasso* tool, and carefully draw around what will be the color subject in the image. Press Shift-Control-I to select the background.

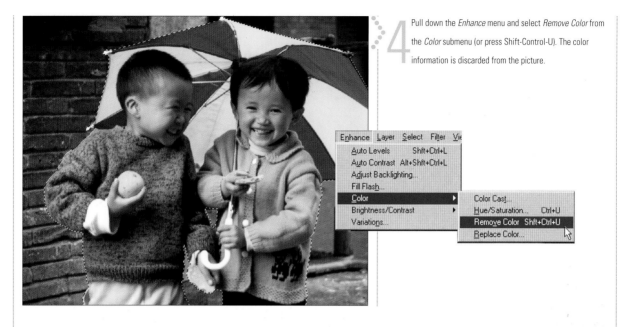

4 Pull down the *Enhance* menu and select *Remove Color* from the *Color* submenu (or press Shift-Control-U). The color information is discarded from the picture.

5 Use the *Clone Stamp* tool to decolorize small areas missed when you have selected the subject with the *Lasso* tool. Next select *Save As* from the *File* menu.

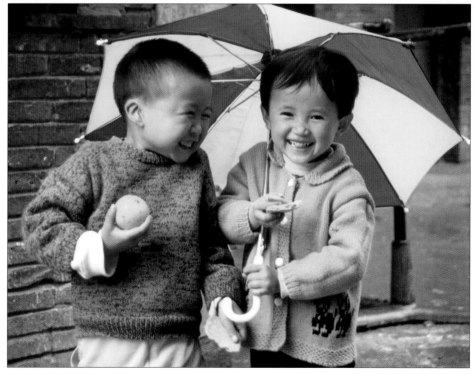

LESSON 13—AIRBRUSHING

It's time to bring it all together and put yourself in the picture using the techniques discussed in this and earlier chapters. If you've ever wanted to stand shoulder to shoulder with Laurel and Hardy or be the fifth Beatle, now's your chance…

Woody Allen and Steve Martin have both starred in movies that featured shots of them spliced with clips of long-dead politicians, gangsters, celebrities, and film stars; even some beer commercials got in on the act. *Zelig* and *Dead Men Don't Wear Plaid* explore the amazing possibilities of using clever camera and editing trickery to fit Allen and Martin into clips filmed years earlier, some from Hollywood, others sourced from newsreels of real-life events. If you have seen either film (but particularly *Zelig*) you'll know how amazing the results can be.

Join the Stars

Now it's your turn. With your digital camera, image-editing software, and the techniques we've worked through elsewhere in the book, cutting in on the action is relatively easy and great fun! Amaze your family and friends and rub shoulders with stars of the past and present. Here's how…

Rewrite History

1 First catch your celebrity! You can use a picture of a politician, actor, sports star, notorious criminal—even a character from history. A picture that features the celebrity alongside another person is best—you can simply substitute yourself for the companion! A word of warning, however, be careful not to infringe any copyright laws if you intend to put your picture up for public consumption.

2 Using the print copying methods discussed earlier, digitize the celebrity picture. A scanner is best for this task but if you don't have one, you can use your digital camera and get reasonable results (see pp.144–145).

3 Ask a friend to take your picture against a neutral background and posed as closely as you can manage to the companion you're going to replace in the original picture. Don't worry too much about relative sizes at this point. Reducing the new shot to match the original won't lose a great deal in quality.

4 Download the picture and open it in your image editor. Next, open and activate the picture of the celebrity. Press Shift-I to summon the *Current Image Information* dialog and make a note of the dimensions. Repeat for your own image and adjust by resizing (*Image> Resize*, or *Shift > S*) to match the two photographs.

HEADS UP

If you're having difficulty matching a full-length picture of yourself against that of the celebrity, try replacing just the face of the companion. With a bit of ingenuity, resizing, cloning work, and some feathering, it's quite easy to blend your face into someone else's.

5 Select your picture and draw around yourself with the *Freehand* tool (try to do this accurately so you pick as little background as possible). Pull down the *Selections* menu and choose *Feather* from the *Modify* submenu (or press *Control > H*). When the *Feather* dialog appears, enter a value of about five pixels. You might need to experiment—the idea is to soften the edges just enough to blend them into the new picture. Press *Shift > Control > I* to select the background and delete it. Right-click to deselect. Press *Control > C* to make a copy of this image in the clipboard.

6 Activate the celebrity image by clicking it. Use the *Clone* tool to remove the greater part of the companion—you can do this quite roughly because your image will overlay the one you're removing. Pull down the *Edit* menu and select *Paste As New Layer* (or press *Control > L*) to paste the clipboard selection into the celebrity picture layer.

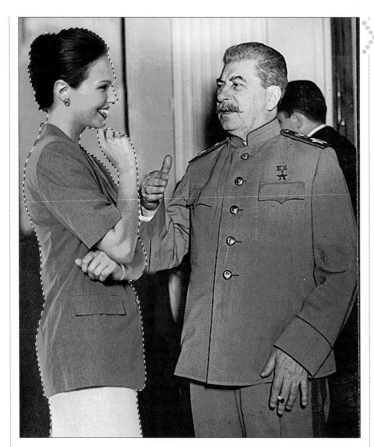

7 Position the layer of you as closely as you can to the original. You can use the *Clone* tool to aid blending.

BLACK AND WHITE BLEND

If you're having trouble blending two color images convincingly, try rendering both as grayscale. The eye can be more easily fooled by the subtle shades of gray.

8 To create an illusion of depth in the picture, you can create more layers by selecting bits of the original picture using the *Freehand* tool, copying them to the clipboard, and pasting them back into the picture as a new layer (*Control > L* again). In this way you can build multilayered pictures that truly blend your image with the original.

9 When the picture appears just as you want it, flatten the layers by selecting *Merge All* from the *Merge* submenu on the *Layers* menu. Finally, *Save As* by pressing Shift-Control-S.

LESSON 14—DELETING RED-EYE

Let's continue the masterclass with a relatively simple yet nevertheless highly useful technique for ridding blighted pictures of the dreaded red-eye phenomenon! This infuriatingly common occurrence is the ruin of thousands of pictures.

Red-eye is caused by light from the camera's flash illuminating, and being reflected by, the subject's retina. It happens because in dim light the pupils open wide to allow more light to enter the eye. The intense flash of light from the flashgun occurs far quicker than the eye can respond, and so it is caught by the camera while wide open, reflecting the light as a red disk.

Red-eye looks particularly unpleasant when it occurs in the eyes of pets such as dogs and cats, and though we've come to live with the phenomenon, it spoils many otherwise excellent photographs. Over the years photographers have developed techniques to try to avoid red-eye. With conventional film you only know red-eye has blighted your pictures when you get them back from the laboratory. Digital photographers can review pictures as they're taken and reshoot as necessary but the potential for red-eye is just as strong a possibility.

Flash Compensation

Many cameras offer a red-eye-beating flash option which fires a pre-exposure flash burst, pauses momentarily while the eye adjusts itself to the new light level, and then fires the flash again. If your camera features red-eye compensation then use it. If you forget, don't have time to set it up, or didn't realize there was a potential for red-eye until you saw the spoiled pictures downloaded to your computer, here's what to do to restore them to good health...

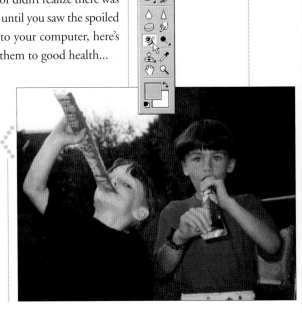

Red Shift

1 Photoshop Elements, Paint Shop Pro and many other image-editing programs provide dedicated tools and filters to enable you to remove red-eye quickly and easily. Shown on these pages is the red-eye removal brush from Elements.

2 Open the picture and click on the red-eye brush to select it. Choose a suitable brush size from the pop-up brush palette in the *Options* bar. Move the tool over the offending red-eye and you'll notice that the color in the *Current* field on the *Options* bar changes to match. By selecting *First Click* from the *Sampling* pop-up menu on the *Options* bar, a simple click on the eye will cause the brush to seek and replace the color you clicked on.

PRO OPTIONS

Paint Shop Pro provides a comprehensively equipped dedicated red-eye dialog box which can make intelligent automatic adjustments to human and animal eyes. There's also a red-eye "quill" to enable you to selectively remove the effect manually and you can select from a range of eye color types (which change in color depending on what you select from the pop-up *Hue* menu).

3 If you click on the *Replacement* field, the *Color Picker* is displayed. You can select a color from this dialog that matches the subject's eyes or elect to use the red-eye defaults (click *Defaults* on the *Options* bar).

4 To remove red-eye enlarge the picture and simply click in the red part of the eye to select it. Elements substitutes the default or custom color previously selected for the offending red. Repeat until all the red has been removed from both eyes and use *Save As* to make a copy of the picture.

The dedicated *Red-eye Removal* dialog box in Paint Shop Pro has a number of preset options that cater for just about every incidence of red-eye, humans and animals!

You can select the color you want your subject's eyes from the millions of colors in the *Color Picker*.

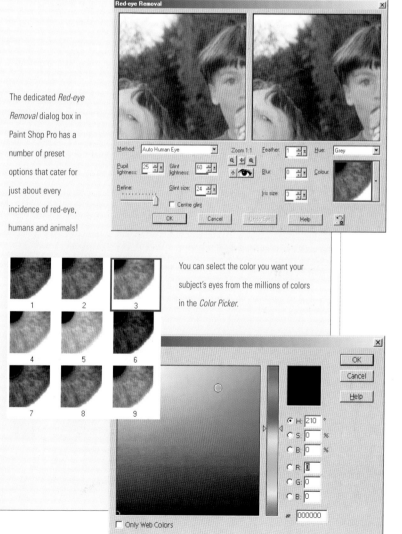

LESSON 15—SIMPLE ANIMATION

Watch the natural world unfold at a rate of knots! Compress time using a special photographic technique known as "time-lapse" and a hidden world around you will spring up before your lens!

Time-lapse is a variation on the theme of movie-making that uses still digital images (explored on the next pages). But unlike creating an animated film using props and stills, time-lapse photography compresses the passage of time into a very short sequence that enables you to see incredible beauty in the natural world which is otherwise missed.

Nature Blossoms

Leaves unfolding, flowers opening, the natural movement of trees, cloud formations moving overhead, seeds sprouting and growing, animated shadows as the sun moves across the sky, the hands of clocks whizzing around—you've probably seen examples of all these "effects" elsewhere, and now you can

recreate them and dream up new examples of your own. How is time compressed in this way? The camera remains still and is set to take a picture at fixed intervals over a period of time: an hour, a day, a week, or whatever. When that sequence of pictures is run together as an animation, the hidden "movement" of the subject—which otherwise occurs so slowly that it cannot be detected—is revealed.

Many digital cameras offer an on-board time-lapse function which you can set to take time-lapse pictures automatically, and thereby simplifying the process enormously. You need only set up the shot and take the first picture, your camera does the rest. However, even cameras that do not offer time-lapse can be used to produce the effect.

Timed to Perfection

1 If your camera provides a time-lapse function, the process is easy. If it doesn't, you can still take great time-lapse sequences, but the onus will be on you to switch on the camera, take the pic, and switch it off again at whatever interval you deem suitable.

2 Set your camera on a tripod before your subject. Switch on the camera's time-lapse mode and select a suitable interval between exposures. This should be long enough to best capture the passing of time as it applies to the subject. If your camera doesn't have time-lapse, it'll be up to you to come and take the picture at the required interval.

3 Press the shutter to take the first picture, then leave the camera to do its work (returning when necessary to fire the shutter if there's no time-lapse function).

4 When the sequence is complete, download each frame to your computer and use animation software (such as Animation Shop from Jasc, the makers of Paint Shop Pro) to join them together in an animated sequence—you'll be amazed at the results!

Animation Wizard

1 Define your animation's total dimensions—including both the width and height—in pixels.

2 After selecting the default color of your canvas, Animation Wizard will ask if you want to automatically resize the images to the animation dimensions previously specified, and where you want the images to be placed.

3 After being asked how often you want the animation to play and the duration of each frame, simply select the images you wish to use in the animation sequence.

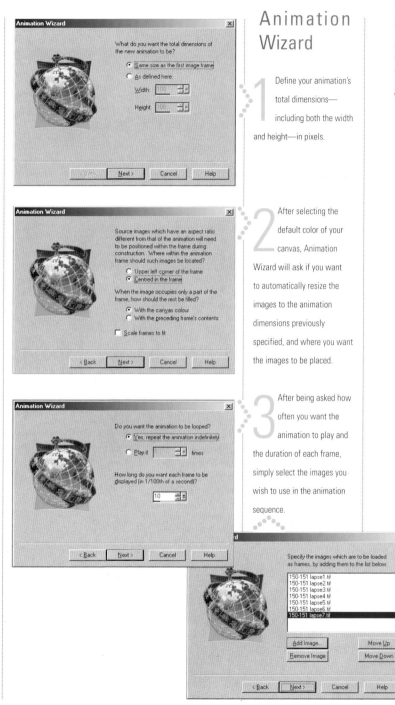

Masterclas

LESSON 16—MAKING MOVIES

Use your still digicam to produce short animated films—or lengthy ones if you have the patience! With a few simple props and a little imagination you can make home movies featuring all kinds of animated characters.

Believe it or not, it's entirely possible to make animated films using your digital camera! The process is laborious and the results can often be a bit hit and miss, but with a little effort and a great deal of patience, it is possible to create short animated films using sequences of still images, a fair amount of imagination, and some ingenuity.

Frame by Frame

The films you see at the cinema are simply many thousands of still images displayed one after the other at several frames per second to give the eye and the brain the illusion of constant movement. By taking sequences of still images with your digital camera you can stitch these together into a slideshow (using an animation program such as JASC's Animation Shop) which, when displayed at a reasonable turn of speed, appears just like any other film.

It isn't really possible, however, to make movies using live actors with this technique—unless you have exceptionally patient friends! But clay models, drawings (known as animation "cells"), characters cut from cardboard or any other inanimate object can be made to "move."

The secret with shooting animation in this way is to ensure that the lighting and position of the camera remains constant, otherwise your animation will not be convincing.

1 You can create amusing animations by taking individual photographs in a sequence. In this sequence the house was built first and then the photos taken in reverse order, dismantling a piece of the building before each shot. This way there is less chance of movement in the setup than there would be while trying to build the house at the same time as taking the pictures. A camera tripod is also useful to help maintain consistency.

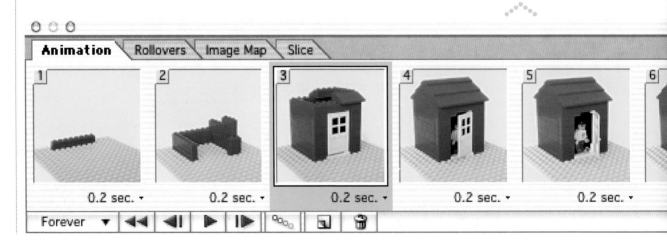

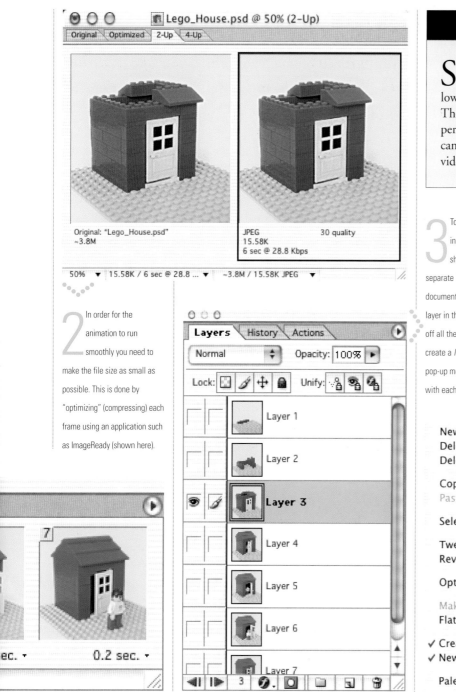

Original: "Lego_House.psd"
~3.8M

JPEG
15.58K
6 sec @ 28.8 Kbps

30 quality

50% ▼ | 15.58K / 6 sec @ 28.8 ... ▼ | ~3.8M / 15.58K JPEG ▼

2 In order for the animation to run smoothly you need to make the file size as small as possible. This is done by "optimizing" (compressing) each frame using an application such as ImageReady (shown here).

CLIP ART

Some cameras offer a movie mode which captures a few seconds of low-resolution video—a "clip." Though these are fun and make perfect extras for a web page, they can't rival the output of a dedicated video camera, digital or otherwise.

3 To create the animation in ImageReady, each shot is placed on separate layers in a single document. Select the first layer in the sequence, turning off all the other layers, and create a *New Frame* from the pop-up menu. Do the same with each layer in turn.

4 You can make the transition from one frame to the next a little smoother by using the *Tween* command. This creates extra frames between pairs of frames that you made by a sort of blending process.

New Frame
Delete Frame
Delete Animation

Copy Frame
Paste Frame...

Select All Frames

Tween...
Reverse Frames

Optimize Animation...

Make Frames From Layers
Flatten Frames Into Layers

✓ Create Layer for Each New Frame
✓ New Layers Visible in All States/Frames

Palette Options...

LESSON 17—PRESERVATION

Render your existing conventional prints as digital photographs and you'll be able to rescue them from flaws and defects as easily as you can with digital pictures. Making copies isn't so difficult and requires little more than the kind of apparatus that you can find about the home…

As you become accustomed to the incredible range of options available to you as a digital photographer, you may come to wish that you could manipulate existing printed photographs in the same way. Just think: all those old prints spoiled by poor lighting, red-eye, fuzzy focusing, scratches on the negatives, tears and dog-ears could be repaired and made… well, better than new! You could rescue and make copies of irreplaceable old prints of your relatives, preserve them for posterity, and make prints to share among your family.

Scan or Shoot

Of course one option would be to invest in a scanner to make scans of your archive material (see page 150). But you can easily digitize your images using a digital camera. The only extra piece of equipment you'll need is a tripod of some description. These are relatively cheap (and you can even fashion a tripod of sorts if you're working to a tight budget), but you'll need to check that your camera has the necessary tripod thread—very cheap cameras often don't. A piece of wood for a baseboard, a couple of anglepoise lamps, and an hour or two to spare, and you'll be able to copy prints easily.

Posterity Prints

1 You'll need a piece of wood for a baseboard for your prints. Any old offcut of wood measuring say, 45x45cm is fine. Paint it mat black if you can (or cover it with a sheet of black crêpe paper available for a few cents from art suppliers if you can't). This will help stop your camera from taking false meter readings.

2 Commandeer the kitchen table for an hour or two and beg, steal, or borrow a couple of anglepoise lamps! Place the baseboard on the table and set the lamps at either side of it so that their light floods across the baseboard at a lowish angle. Don't switch on the lamps yet (otherwise the print will curl in the heat from the bulbs).

3 Lay your print face-up on the baseboard. If it begins to curl, use a couple of rulers (or similar) laid along the edges to hold it flat. Position your camera on its tripod directly over the print so that the lens is at a right angle to it and between 30 and 45cm away.

4 Now you'll discover why an LCD preview screen and a zoom lens can be so useful! Switch on the camera and use the zoom lens to fill as much of the LCD screen as you can with the print. It's certain that you'll need to shuffle the tripod around slightly, and make various small adjustments to get everything to line up, but persevere—the results are worth it!

5 Switch on your camera's timer function. Switch on the anglepoise lamps. Squeeze the shutter button to focus, then fire the shutter. Let go of the camera, stand back so that you're not casting a shadow across the print, and let the camera take the picture.

6 Review and repeat as necessary using any features your camera has, such as EV compensation, white balance, and macro focus to make the best possible copy. Don't discard any of the exposures you make until you've reviewed them all on your computer screen. It may be possible to make a better picture from a poor but digitally edited image.

7 Save, then use the tools and filters described elsewhere in this book to clean up and repair the print as necessary. *Save As,* and then commit the image to paper—you'll be amazed at the results!

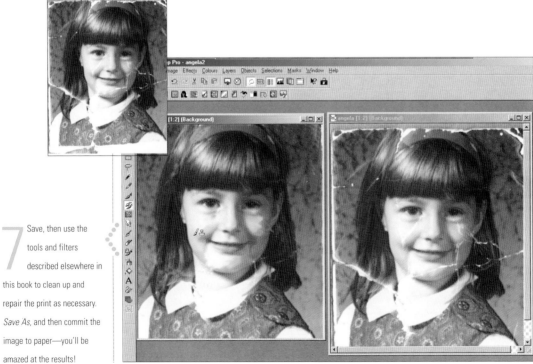

SCANNERS AND SCANNING

If you have a lot of prints that you'd like to rescue, then invest in a flatbed scanner. This is a device that makes high-resolution copies of photographs, transparencies—in fact anything you place on its glass scanning window. Resolution is typically 1200x1200dpi and prices have never been cheaper. Advances in technology and manufacturing mean that you can get a scanner for home use for around $70, though a "transparency hood" (a specially adapted lid that enables a transparency to be scanned) will increase the price significantly. Many image-editing packages support scanners directly—you can acquire the scanned image from your scanner directly into your favorite image editor.

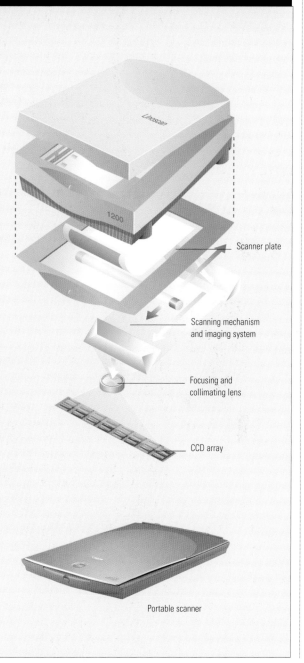

Scanner plate

Scanning mechanism and imaging system

Focusing and collimating lens

CCD array

Transparency scanner

Flatbed scanner

Portable scanner

Proving the Pudding

Until it's printed, a digital photograph is no more than a collection of bits and bytes. True, you can create spectacular slideshows of your images on a computer, mail pictures to websites and newsgroups, and email them to your friends, but the proof of the pudding, the reality of a picture for most people, is when it's printed and displayed in a way that everyone can enjoy—even those without computers. Fortunately, high-quality printers have never been cheaper and the technology is relatively easy to use. As always though, an insight or two will enable you to really get the most from what the printer has to offer the digicam owner.

PRINTS AND PAPER

Printing is when your previously digital images stored as bits of data on a computer become—in the eyes of most people at least—real photographs, something tangible that you can share among friends or flick through in the pages of an album...

Until now, your digital photographs have been just that: digital. No matter how well you've taken, edited, stored, or manipulated them, the pictures have only existed virtually, and been as real as a computer-generated representation can be. One tiny electrical glitch between camera and computer, and those precious bits of data could disappear forever. Of course, such glitches are rare, and once your images are held on a storage card, they're at least as safe as a package of prints. But maybe now is the time to return to the "real world," and actually reproduce your pictures as a series of prints.

No Place like Home

There's never been a better time to explore printing at home. The technology has advanced in leaps and bounds, and today you can buy a color printer that offers truly amazing resolution and depth of color at well under $150. Use the device with purpose-made glossy photographic paper, and you'll create images with a quality that rivals many commercial processing outlets.

Possibly the most obvious way to display your digital photographs is to gather them together in an album of some kind. Choose one without plastic curtains, however, or pictures generated on inkjet printers will soon discolor, and may even fade completely!

Digital editing and printing techniques can help you produce a stunning physical album of montages, effects, and textures that will lift your pictures off the page.

Many Happy Digital Returns

Another good print option is to select a favorite picture and turn it into a greetings card. Many laser printers and most inkjets will print quite happily on relatively heavyweight paper or greetings card paper made especially for the purpose, such as Kodak's Linen Premium Greeting Card paper. If yours won't print on heavier media, try printing on normal-weight paper and include trim marks; glue to pre-prepared cardboard blanks and trim to finish. And if you tailor the picture to a particular season such as Valentine's or Mother's Day, so much the better!

Been There, Got the T-shirt

Broadcast your images to the world by printing one on a T-shirt. It's easy if you use iron-on transfer paper from specialist photo-graphic suppliers and the results can be very good indeed. Add interest by making a montage of several pictures, insert a humorous caption, or manipulate an image to create a truly spectacular effect.

MAKING CONTACT

Conventional camera buffs, those with a home darkroom, often make "contact" prints—direct prints from the negative without enlarging—which enable the photographer to get some idea of what the completed print will look like, but without wasting lots of expensive photographic paper in the process. By comparison, digital photographers have it easy. You can view your images onscreen, selecting only those that meet your approval for editing and ultimately printing. However, a digital "contact" print, a single letter sheet filled with the pictures from a particular set (and we'll discuss filing systems later in this chapter) serves a real purpose in enabling you to sift through photographs and easily select say, the particular CD-ROM on which they're stored. It also makes for a pleasant hour or two spent poring over your hard-earned pictures!

The unique advantage of digital images is that they can be output onto as many media as exist, simply by handing the file over to a specialist supplier, or mailing it to a specialist website. Mugs, bed linen, mousemats, posters, stationery... you name it, it's possible.

HARD AND FAST

Time was when the humble dot matrix and office daisywheel were the only way to get computers to print something. Now an enormous range of high-quality inkjets and some spectacular laser printers and dye-subs provide near professional-quality output at home.

Printers, much like digital cameras (and perhaps even because of them!), have come a long way in the past five years or so. From being large-footprint, low-resolution devices that offered little in the way of color, printer technology has advanced to the point to which it's feasible to print photorealistic pictures at home with very little fuss. What's more, you can buy printers that combine the functions of a scanner and a fax machine too, so that as well as being able to print digital images from your computer, you can scan traditional photographs and edit and combine them with pictures from your digital camera. The digital darkroom has truly come of age—and at an affordable price.

A Non-PC Solution

For those without a computer and who don't want to own one, many manufacturers offer printers that accept storage cards direct from the camera—eject the card from the camera, pop it into the printer, and use the latter's own functions to select from a range of printing, resizing, and cropping options for true versatility, albeit without true editing options.

Resolution is as much an issue for printers as it is for cameras, although printer resolu-tion is generally measured in dots per inch (dpi) rather than pixels per inch. Even entry-level inkjet printers typically have a resolution of 1200x1200dpi—which is regarded as photo-quality, while most of today's midrange laser printer typically offer 1200x600dpi: still perfectly acceptable.

Desktop inkjet printers are a low-cost means to a high-quality end, but you'll quickly use up the color cartridges if you print out a lot of images or copies. Good-quality paper makes for professional results.

Inkjets

Inkjets (sometimes known as "bubblejets") are the workhorses of the printing world. They're easy to use and set up, and ink cartridges are affordable, widely available, and occasionally refillable! Resolution is of the order of 1200x1200dpi, but spending just a little more than entry-level prices will get you double that—which is more than adequate for quality home printing, especially if you use photo-quality glossy paper.

An inkjet requires only a small amount of space on your desktop, produces little noise

and no fumes (unlike laser printers), so they're ideal where space is at a premium, such as when sharing a computer system with the rest of the family, or if you have a home office. A reasonable quality entry-level color inkjet printer should cost no more than $100-$125. $200-$240 will get you a fast, high-resolution inkjet capable of near-commercial results.

Lasers

Laser printers were once only for media professionals. Laser printers continue to be pricey, toner cartridges are expensive, they belch out truly horrible (and unhealthy) fumes, and the noise of the cooling fan alone is enough to destroy the creative muse. Although at their best lasers offer photo-quality and can output faster than inkjets, even a basic color laser printer will cost you more than $1400. But the gains in speed are not worth the expense, the noise, and the toner pollution, particularly when the output quality is likely to be less good than an inkjet.

Dye-subs

Dye-sublimation printers ("dye-subs") transfer color ink to special paper using heat to build the image (they are also known as "thermal printers"). Another type uses beams of ultra-violet light to create the image using dye-impregnated paper. Quality can be high, but so can the cost. Sublimation printers are slow, don't reproduce type well (so can't really be shared with the family), and output is small compared with other types (often only A6 100x148mm), but the future promises much for the technology. Expect to pay about $500.

(*Left*) The image shows just how far inkjet printers have come in the last two to three years. Colors are vibrant and resolution on most models is excellent. It is only really close up that the image starts to degrade.

PAPERWEIGHTS

Paper quality—finish, weight, chemical additives, and fiber density—can have a profound effect on the way your digital images reproduce as prints, and on their lifespan too. Don't turn that page!

Your choice of paper is as important—arguably more so—than your choice of printer. Even a humble inkjet will produce good prints of your digital images (as long as they're of reasonable resolution in the first place), but choose the "wrong" paper and you're guaranteed to be disappointed with the results. However, the increasing popularity of digital photography has brought with it an awareness of photographers' requirements, and photo-quality printing papers and inks, ultra-fast printers, ultraviolet-shielded picture frames, and other goodies are now available to assist you.

It is certainly possible to print photographs at home that rival the quality of commercial processing and printing, and a little experimenting with papers and inks, together with a certain amount of care with the finished prints, will produce good results.

Photo Ink

And it isn't just the paper that will affect your print quality—ink too has a part to play. Some manufacturers offer specially formulated photo printing inks. These are expensive but they're ideally suited to use with photo papers. A photo ink cartridge replaces the black cartridge in your inkjet printer, sitting alongside the tri-color one.

Paperstocks Explained

Budget-priced copier paper

Main-street stationery suppliers often have reams of copier paper at very low prices. Although these are fine for pages of text, the coarse fibers in this poor-quality paper tend to diffuse ink, creating a dot-gain effect that reduces the effective resolution. Use a lot of this cheap paper and over time, you'll find that the delicate mechanisms within your printer become clogged with paper dust (fibers that have broken free). It's best used only for thumbnails and test prints (proofs) or alignments. Or for work while you're still learning and experimenting, before you print out your newly expert images!

Ordinary printer/copier paper

Good-quality printer and copier paper has densely packed, fine fibers that inhibit ink diffusion, and thereby create slightly better prints. However, you'll pay more than twice as much for a ream as for budget copier paper, and the results from digital images still won't be anywhere near as good as those from photo papers. Color reproduction and contrast will appear dull, flat, and lifeless (by comparison), though it won't clog your printer as readily as

the cheap stuff! Good for test prints and thumbnails/image catalog prints—and photographs if you're on a tight budget.

Coated paper/inkjet paper

Coated printer paper (sometimes sold as "inkjet paper") is intended for color image outputting. It contains clay and other additives, which inhibit ink diffusion and smudging and which help make inks "fast" (fixed), although ultraviolet light can still have an adverse affect. The quality of digital images printed on coated paper is significantly improved over the other "ordinary" paper types. Use for everyday prints.

Glossy photo paper

As you might expect, glossy photo paper is the best of all for printing digital photographs. Intensely white and with a coating that lends a vibrancy to colored printer inks, glossy photo paper is as close as you'll get to commercially printed photographs. It's expensive, but the results will almost certainly be worth it. Use for your favorite prints and to enlargements—those you want to frame, perhaps.

Tiger, tiger, burning bright... but not in the forests of poor-quality paper. The image (*right*) shows just how well a good-quality photo paper can bring your images to life, and make them as crisp as they appeared on your computer monitor.

MAIN STREET CONFIDENTIAL

If you don't yet own a printer but want the convenience of paper-based pictures, take advantage of the increasing number of main-street processing outlets that offer a variety of digital output services.

There's one very real "danger" when using a digital camera: that many of your photographs will remain only as bits of data on a computer. In one sense, that's a bonus because you have the opportunity to review and edit each image before committing it to print, but once the initial excitement of instant digital photography has worn off, it's sometimes an effort to muster the energy even to bother to switch on your computer, let alone spool through hundreds of images, selecting, editing, and printing them. At times like that, the thought of simply collecting a package of pictures from a main-street photographic processing service and flicking through them in the comfort of your favorite armchair can be an attractive one indeed!

Bureaux of Change

Even if some of the pictures are a disappointment—if only you'd cropped that image, or painted in a different sky!—the ease with which you can enjoy them without the buzz of a computer and the whir a of a printer is a weighty counterbalance to inconvenience. And that's not all. Few are the friends who want to stand by your computer to see your pictures—they'd far rather be handed a sheaf of photographs to flick through and share.

What many digital photographers don't realise is that main-street processing is entirely possible even if you're using the very latest in digital marvels. Many traditional processing labs will cheerfully accept your digital memory cards and hand you back a package of glossy prints, just as if you'd given them a conventional film for processing!

Commercial Breakdown

Before you try, there are several things to bear in mind—the first and most important is don't hand over your card direct from your camera—unless you're absolutely sure that what's stored there is fit for reproduction!

Apple's iPhoto service is a major innovation for digital photographers, and you don't have to own a Mac to enjoy it. Simply post your digital images onto the site, select the layout style and type of album you want and, within a few days, iPhoto will send you your album with the photos printed and placed on the page as requested. Easy!

ONLINE OUTPUT

In the spirit of all things digital, some Web-based processing services can accept emailed images and will send prints by return in the mail. This is an option that's really only worth considering if you have a high-speed Internet, such as ISDN or, better still, broadband (such as ADSL).

iPhoto offers an amazing variety of options once you have loaded your images into the software. You can arrange for albums to be made, view them in a slide show, and undertake minor editing tasks before printing them.

1 Download your pictures to your computer, and select those fit for printing. Next, edit the selected images so that you can be sure they'll be reproduced at their best. Balance contrast, brighten colors, and tweak backgrounds and composition.

2 Crop! This is the most important step, because your pictures will be reproduced as enprints—that is, measuring 2x4 inches. The images will be centered over this measurement before they're printed, and anything that falls outside the area is cropped!

3 A good way to crop for enprints is to create a mask. Using PSP, choose *New* or press *Control > N* and use the pop-up measurement menu on the *New Image* dialog to select inches. Now enter 4 and 2 into the relevant fields.

4 Browse to your image selection, choose one and open it. Now press *Control > C* to make a copy on the pasteboard. Next select the mask image by clicking on it and press *Control > E* to paste your image from the pasteboard into the mask. Move the image around until it's cropped exactly how you want it.

5 Press F12, enter a suitable name for the new image, select *File Type JPEG* and save it. Repeat steps 5–7 for all the images in your selection.

6 Download your edited and cropped images to your digital storage card and take it to the processing service.

iPhoto also features software that enables you to set up a slide show. Once you have placed your images into iPhoto and select *Export> QuickTime*, you can select how long each image is displayed, its size, and even appropriate music!

RANK AND FILE

Digital photography positively encourages you to get out there and take lots of pictures! Not for digital photographers the worry of wasting expensive film, nor the concerns over processing costs for pictures which might never see the light of day…

With a digital camera you can take endless pictures and store thousands of them on even a modest modern PC or Mac with little fear of running out of space. But the only way you'll find an image is by establishing a filing system and sticking to it. Fortunately for owners of new PCs, Windows XP is a great aid in that it provides all kinds of tracking tools to enable you to store, browse, and watch slideshows of your pictures. Similarly, Mac OS X on new models provides similar facilities in its iPhoto software options.

If you want to create a more permanent store, a CD burner (data recorder) is a must. Arguably the perfect storage medium, CDs are thought to have a shelf life of around 100 years, so it'll be a while yet before you have to consider updating and refreshing your picture archive! Hi-fi CD recorders are not suitable.

Windows XP (pictured), available preinstalled on new PCs or as separate software, contains many useful image filing and storage facilities so you can keep track of your growing library of pictures. Mac OS X (not pictured) includes similar functions and some handy extra options in its iPhoto package.

As the digital age allows different media—such as digital photography, digital video and audio, and animation—to merge, Windows XP also lets you manage your work across media, and across devices.

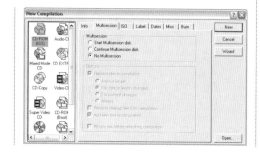

CD Burning—PC

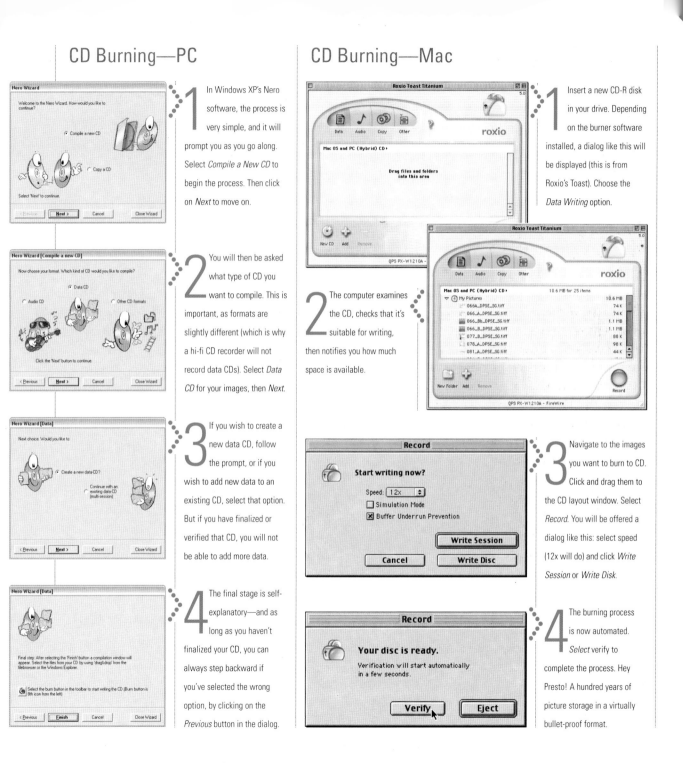

1 In Windows XP's Nero software, the process is very simple, and it will prompt you as you go along. Select *Compile a New CD* to begin the process. Then click on *Next* to move on.

2 You will then be asked what type of CD you want to compile. This is important, as formats are slightly different (which is why a hi-fi CD recorder will not record data CDs). Select *Data CD* for your images, then *Next*.

3 If you wish to create a new data CD, follow the prompt, or if you wish to add new data to an existing CD, select that option. But if you have finalized or verified that CD, you will not be able to add more data.

4 The final stage is self-explanatory—and as long as you haven't finalized your CD, you can always step backward if you've selected the wrong option, by clicking on the *Previous* button in the dialog.

CD Burning—Mac

1 Insert a new CD-R disk in your drive. Depending on the burner software installed, a dialog like this will be displayed (this is from Roxio's Toast). Choose the *Data Writing* option.

2 The computer examines the CD, checks that it's suitable for writing, then notifies you how much space is available.

3 Navigate to the images you want to burn to CD. Click and drag them to the CD layout window. Select *Record*. You will be offered a dialog like this: select speed (12x will do) and click *Write Session* or *Write Disk*.

4 The burning process is now automated. *Select* verify to complete the process. Hey Presto! A hundred years of picture storage in a virtually bullet-proof format.

VCD slideshows

1 There are many programs available (some freely downloadable from the Web) that enable you to create slideshows of your favorite images. If the slideshow is saved in what's known as the VCD format, a special method for burning, the resulting disk can be used with a domestic DVD player or TV, as well as a computer.

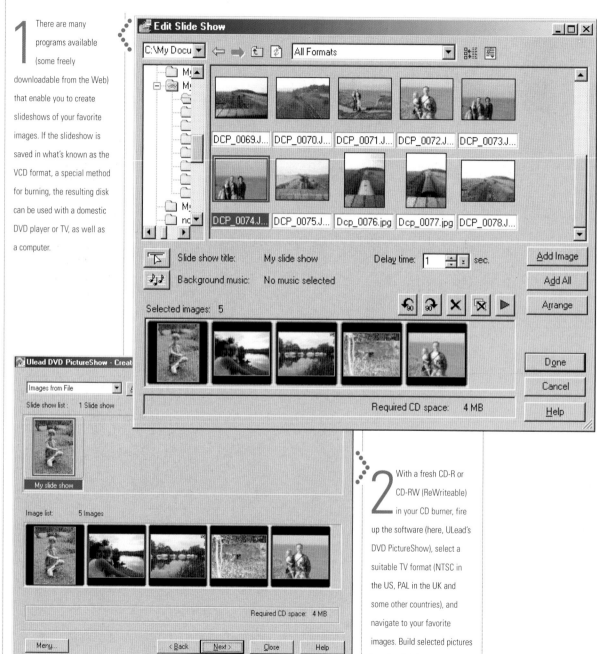

2 With a fresh CD-R or CD-RW (ReWriteable) in your CD burner, fire up the software (here, ULead's DVD PictureShow), select a suitable TV format (NTSC in the US, PAL in the UK and some other countries), and navigate to your favorite images. Build selected pictures into the slideshow.

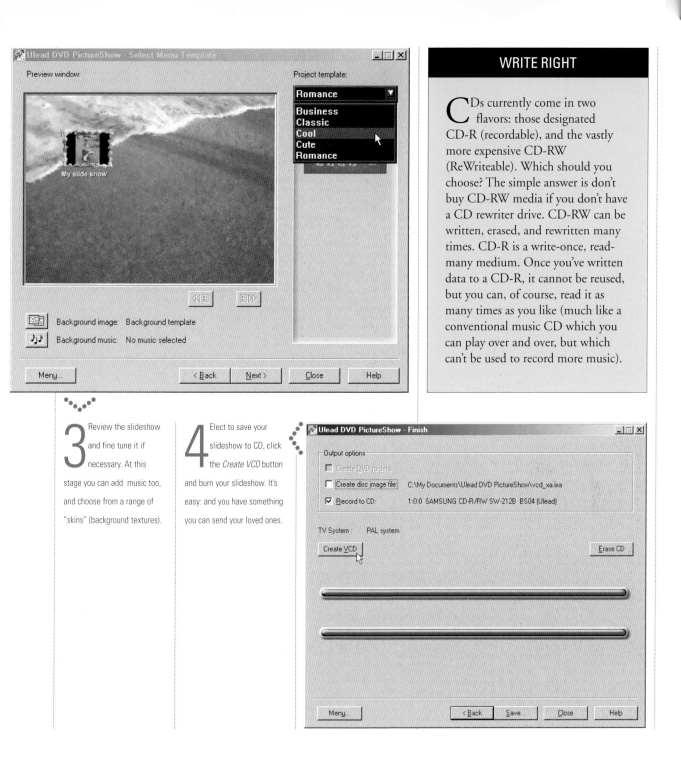

3 Review the slideshow and fine tune it if necessary. At this stage you can add music too, and choose from a range of "skins" (background textures).

4 Elect to save your slideshow to CD, click the *Create VCD* button and burn your slideshow. It's easy: and you have something you can send your loved ones.

POST HASTE

Once upon a time if you wanted to mail photographs to your friends and relatives you had to find a padded envelope or corrugated stiffener inserts, pay the extortionate postage required for anything heavier than air-mail paper, and wait the week or so until they were delivered. Nowadays, there's email…

Unlike conventional paper-based communications email is more or less instant. Write your email, address it, and click the Send button. A fraction of a second later the recipient can be reading it, wherever they are, as long as they have access to a computer and telephone line. And what's good for simple text messages can also be used for sending pictures—though a certain amount of "cheating" is required.

Encoded Only

Designed as a text-only medium, the underlying email technology has to be fooled into believing that what is being sent consists only of plain text. Send a picture with an email as an "attachment" and it must undergo a process known as "UUencoding" (it is said to be "UUencoded'). This means that the data that describes the digital picture is made to look like plain text to the email server. As you might imagine, a UUencoded email must be UUdecoded at the receiving end—its data reconstituted as that which will create a picture. Once, the encode/decode process was manual—you had to feed your attachments to a separate utility program. Now the email client (the software you use to send emails) does the encoding and decoding for you, on the fly.

Steps to Send

1 To send a digital photograph as an attachment, first use your favorite image-editing software to reduce its size as far as possible by resizing and even resampling if necessary.

2 A compression program such as WinZip (PC) or StuffIt (Mac) should be used to reduce file sizes. But heavily compressed picture formats, such as GIF, won't compress much further through such software.

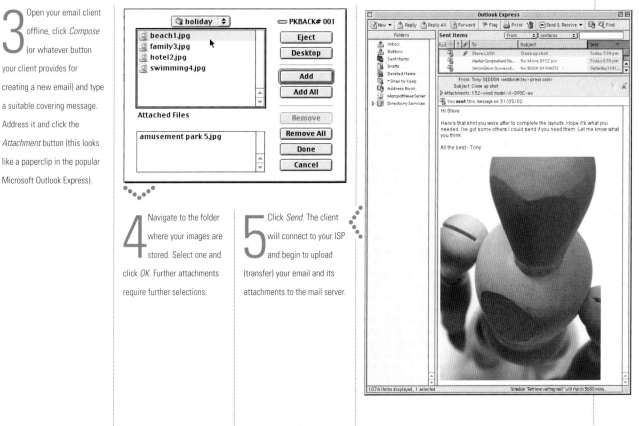

WORDS TO THE WISE

While it's perfectly possible to send digital images as email attachments, it isn't always sensible. Most people collect their domestic email with a 56Kbps connection via a home computer and a telephone line. Even one digital photograph can be several Megabytes in size. Attach an album's worth and the recipient could be downloading for days! What's more, many ISPs place a restriction on the size of mailboxes—send an email with many large attachments and you might find it's simply bounced back to you.

3 Open your email client offline, click *Compose* (or whatever button your client provides for creating a new email) and type a suitable covering message. Address it and click the *Attachment* button (this looks like a paperclip in the popular Microsoft Outlook Express).

4 Navigate to the folder where your images are stored. Select one and click *OK*. Further attachments require further selections.

5 Click *Send*. The client will connect to your ISP and begin to upload (transfer) your email and its attachments to the mail server.

GLOSSARY

A

Adobe Inc. US company that develops software for specialist, creative tasks such as Web design, graphic design, and video editing. Its products are widely used by both professionals and amateurs. Photoshop, Photoshop Elements, and the video-editing package Premiere are some of its most successful software products.

alpha channel A grayscale version of an image that can be used in conjunction with the other three color channels, such as for creating a mask.

animation The process of creating a moving image by rapidly moving from one still image to the next. Animations are now commonly created by means of specialist software that renders sequences in a variety of formats, typically QuickTime, AVI, and animated GIF.

anti-aliasing The smoothing of jagged edges on diagonal lines created in an imaging program, by giving intermediate values to pixels between the steps.

application Software designed to make the computer perform a specific task. So, image-editing is an application, as is word-processing. System software, however, is not an application, as it controls the running of the computer.

artifact Any flaw in a digital image, such as "noise." Most artifacts are undesirable, although adding "noise" can create a desirable grainy texture if the image is appropriate.

B

back-up A copy of either a file or a program created in case the original becomes damaged (corrupt) or lost.

bit depth The number of bits-per-pixel (usually per channel, sometimes for all the channels combined), which determines the number of colors it can display. Eight bits-per-channel are needed for photographic-quality imaging.

bitmapped graphic An image made up of dots, or pixels, and usually produced by painting or image-editing applications (as distinct from the vector images of "object-oriented" drawing applications). The more pixels used for one image, the higher its resolution. This is the normal form of a digital or scanned photograph.

browser/Web browser Program that enables the viewing or "browsing" of World Wide Web pages across the Internet. The most commonly used browsers are Netscape's Navigator and Microsoft's Internet Explorer. Version numbers are important, as these indicate the level of HTML that the browser supports. Another browser, "Opera," is competitive because of its compact size, efficient performance, and security. It is rapidly gaining popularity.

burn(ing) The act of recording data onto a CD in a CD burner (recorder). Software such as Roxio's Toast (Mac) is used for this task when recording from a computer to an external device.

byte Eight bits—the basic data unit of desktop computing.

C

CD-ROM CD (Compact Disk) Read-Only Memory. An evolution of the CD allowing the storage of up to 600 Megabytes of data, such as images, video clips, text, and other digital files. But the disks are "Read only," which means the user can't edit or overwrite the data.

CD-R/CD-RW CD Recordable/CD-ReWriteable. CD-Rs are inexpensive disks on which you can store any digital data, or roughly 77 minutes of audio (on a hi-fi CD recorder). But once written and finalized (fixed), the data cannot be erased, edited, or modified. Similar to the above, CD-RW disks can be "unfinalized" then

overwritten, in part or entirely, any number of times. However, CD-RWs will not play on every type of device—a CD-RW recorded on a hi-fi type of CD recorder will not play on most other CD players.

channel Part of an image as stored in the computer; similar to a layer. Commonly, a color image will have a channel allocated to each primary or process color, and sometimes one or more for a mask or other effect.

clone/cloning In most image-editing packages, Clone tools allow the user to sample pixels (picture elements) from one part of an image, such as a digital photograph, and use them to 'paint' over other areas of the image. The process is useful for removing unwanted parts of an image, or correcting problems, such as closed eyes if the subject blinked while being photographed. In Photoshop and Photoshop Elements, the tool is known as the Rubber stamp.

color depth See BIT DEPTH

color gamut The range of color that can be produced by an output device, such as a printer, a monitor, or a film recorder.

color picker The term describing a color model when displayed on a computer monitor. Color pickers may be specific to an application such as Adobe Photoshop, a third-party color model such as PANTONE, or to the operating system running on your computer.

compression The technique of rearranging data so that it either occupies less space on disk, or transfers faster between devices or over communication lines. For example, high-quality digital images, such as photographs, can take up an enormous amount of disk space, transfer slowly, and use a lot of processing power. They need to be compressed (the file size needs to be made smaller) before they can be published on the Web, as otherwise

they would take too long to appear onscreen. But compressing them can lead to a loss of quality. Compression methods that do not lose data are referred to as "lossless," while "lossy" describes methods in which some data is lost.

continuous-tone image An image, such as a photograph, in which there is a smooth progression of tones between black and white.

contrast The degree of difference between adjacent tones in an image from the lightest to the darkest. "High contrast" describes an image with light highlights and dark shadows, but with few shades in between; while a "low contrast" image is one with even tones and few dark areas or highlights. These settings are usually editable.

copyright The right of a person who creates an original work to protect that work by controlling how and where it may be reproduced.

copyright-free A misnomer used to describe ready-made

resources, such as clip-art. In fact, these resources are rarely, if ever, "copyright free." Generally it is only the licence to use the material which is granted by purchase. "Royalty free" is a more accurate description.

D

digitize To convert anything, for example, text, images, or sound, into binary form so that it can be digitally processed. In other words, transforming analog data into digital data.

dithering The technique of appearing to show more colors than are actually being used, by mingling pixels. A complex pattern of intermingling adjacent pixels of two colors gives the illusion of a third color, although this gives a much lower resolution.

dots per inch (dpi) A unit of measurement used to represent the resolution of devices such as printers and imagesetters and also, erroneously, monitors and images, whose resolution should more properly be

expressed in pixels per inch (ppi). The closer the dots or pixels (the more there are to each inch) the better the quality. Typical resolutions are 72 ppi for a monitor, 600 dpi for a laser printer, and 2,450 dpi (or more) for an imagesetter.

download To transfer data from a remote computer, such as an Internet server, to your own. The opposite of upload.

DVD Digital Video (or Versatile) Disk. Similar in appearance to CDs and CD-ROMs, DVDs have a storage capacity of up to 18 Gigabytes, far higher than CD-ROMs (600 Megabytes), and can deliver data at a higher rate. This allows DVDs to store up to 10 hours of high-quality MPEG-2 video, and more than 30 hours of medium-quality (more highly compressed) MPEG-1 video footage. DVD drives (players) are becoming standard on many new PCs, and DVD writers will become far less expensive in the near future.

E

EPS (Encapsulated PostScript) Image file format for object-oriented graphics, as in drawing programs and page-layout programs.

extract A tool and a process in many image-editing applications, such as Photoshop Elements, which allows the selection of part of an image (using the selection tools) and the removal of areas around it, so the subject is extracted from the picture.

Eyedropper tool In some applications, a tool for gauging the color of adjacent pixels.

F

file extension The term describing the abbreviated suffix at the end of a filename that describes either its type (such as .eps or .jpg) or origin (the application that created it, such as .qxp for QuarkXPress files).

file format The way a program arranges data so that it can be stored or displayed on a computer. Common file formats are TIFF and JPEG for bitmapped image files, EPS for object-oriented image files, and ASCII for text files.

FireWire A type of port connection that allows for high-speed transfer of data between a computer and peripheral devices.

frame A single still picture from a movie or animation sequence. Also a single image from a TV picture.

font Set of characters sharing the same typeface and size.

font file The file of a bitmapped or screen font, usually residing in a suitcase file on Mac computers.

G

GB (GigaByte) Approximately one billion bytes (actually 1,073,741,824)

GIF (Graphics Interchange Format) One of the main bitmapped image formats used on the Internet. GIF is a 256-color format with two specifications, GIF87a and, more recently, GIF89a, the latter providing additional features such as the use of transparent backgrounds. The GIF format uses a "lossless" compression technique, or "algorithm," and thus does not squeeze files as much as the JPEG format, which is "lossy." For use in Web browsers JPEG is the format of choice for tone images, such as photographs, while GIF is more suitable for line images and other graphics.

graduation/gradation/ gradient The smooth transition from one color/tone to another. The relationship of reproduced lightness values to original lightness values in an imaging process, usually expressed as a tone curve.

H

histogram A "map" of the distribution of tones in an image, arranged as a graph. The horizontal axis is in 256 steps from solid to empty, and the vertical axis is the number of pixels.

HSL (Hue, Saturation, Lightness) A color model

based upon the light transmitted either in an image or in your monitor—hue being the spectral color (the actual pigment color), saturation being the intensity of the color pigment (without black or white added), and brightness representing the strength of luminance from light to dark (the amount of black or white present). Variously called HLS (hue, lightness, saturation), HSV (hue, saturation, value) and HSB (hue, saturation, brightness).

hue A color found in its pure state in the spectrum.

I

icon An on-screen graphical representation of an object (such as a disk, file, folder, or tool) or a concept, used to make identification and selection easier.

interface This is a term most often used to describe the screen design that links the user with the computer program or website. The quality of the user interface often determines how well users will be able to navigate

their way around the pages within the site.

interpolation Bitmapping procedure used in resizing an image to maintain resolution. When the number of pixels is increased, interpolation fills in the gaps by comparing the values of adjacent pixels.

ISP (Internet Service Provider) An organization that provides access to the Internet. At its most basic this may be a telephone number for connection, but most ISPs provide email addresses and webspace for new sites.

J

JPEG, JPG The Joint Photographics Experts Group. An ISO (International Standards Organization) group that defines compression standards for bitmapped color images. The abbreviated form, pronounced "jay-peg," gives its name to a "lossy" (meaning some data may be lost) compressed file format in which the degree of compression from high compression and low quality,

to low compression and high quality, can be defined by the user.

K

KB (KiloByte) Approximately one thousand bytes (actually 1,024).

L

lasso A selection tool used to draw an outline around an area of the image.

layer One level of an image file, separate from the rest, allowing different elements to be edited.

lines per inch (lpi) Measure of screen and printing resolution.

lossless/lossy Refers to the data-losing qualities of different compression methods. "Lossless" means that no image information is lost; "lossy" means that some (or much) of the image data is lost in the compression process (but the data will download quicker).

luminosity Brightness of color. This does not affect the hue or color saturation.

M

mask A grayscale template that hides part of an image. One of the most important tools in editing an image, it is used to make changes to a limited area. A mask is created by using one of the several selection tools in an image-editing program; these isolate a picture element from its surroundings, and this selection can then be moved or altered independently.

MB (MegaByte) Approximately one million bytes (actually 1,048,576).

menu An on-screen list of choices available to the user.

midtones/middletones The range of tonal values in an image anywhere between the darkest and lightest, usually referring to those approximately halfway.

multimedia Any combination of various digital media, such as sound, video, animation, graphics and text, incorporated into a software product or presentation.

N

noise Random pattern of small spots on a digital image that are generally unwanted, caused by non-image-forming electrical signals. Noise is a type of artifact.

P

pixel (picture element) The smallest component of any digitally generated image, including text, such as a single dot of light on a computer screen. In its simplest form, one pixel corresponds to a single bit: 0 = off, or white, and 1 = on, or black. In color or grayscale images or monitors, one pixel may correspond to several bits. An 8-bit pixel, for example, can be displayed in any of 256 colors (the total number of different configurations that can be achieved by eight 0s and 1s).

pixels per inch (ppi) A measure of resolution for a bitmapped image.

plug-in Subsidiary software for a browser or other package that enables it to perform additional functions, e.g., play sound, movies, or video.

PNG (Portable Network Graphics) A file format for images used on the Web, which provides 10–30% "lossless" compression. It was created as an alternative to the GIF file format.

R

RAM (Random Access Memory) The working memory of a computer, to which the central processing unit (CPU) has direct, immediate access.

raster(ization) Deriving from the Latin word "rastrum," meaning "rake," the method of displaying (and creating) images employed by video screens, and thus computer monitors, in which the screen image is made up of a pattern of several hundred parallel lines created by an electron beam "raking" the screen from top to bottom at a speed of about one–sixtieth of a second. An image is created by varying the intensity of the beam at successive points along the raster. The speed at which a complete screen image, or frame, is created is called the "frame" or "refresh" rate.

rasterize(d) To rasterize is to electronically convert a vector graphics image into a bitmapped image. This may introduce aliasing, but is often necessary when preparing images for the Web; without a plug-in, browsers can only display GIF, JPEG, and PNG image files.

resolution (1) The degree of quality, definition, or clarity with which an image is reproduced or displayed, for example in a photograph, or via a scanner, monitor screen, printer, or other output device.

resolution (2) monitor resolution, screen resolution The number of pixels across by pixels down. The three most common resolutions are 640 x 480, 800 x 600 and 1,024 x 768. The current standard webpage size is 800 x 600.

re-sampling Changing the resolution of an image either by removing pixels (lowering the resolution) or adding them by interpolation (increasing the resolution).

RGB (Red, Green, Blue) The primary colors of the "additive" color model, used in video technology, computer monitors, and for graphics such as for the Web and multimedia that will not ultimately be printed by the four-color (CMYK) process. CMYK stands for "Cyan, Magenta, Yellow, Black."

ROM (Read-Only Memory) Memory, such as on a CD-ROM, which can only be read, not written to. It retains its contents without power, unlike RAM.

Rubber stamp A paint tool in an image-editing program that is used to clone one selected area of the picture onto another. It allows painting with a texture rather than a single tone/color, and is particularly useful for extending complex textures such as vegetation, stone, and brickwork.

S

software Programs that enable a computer to perform tasks, from its operating system to job-specific applications such as image-editing programs and third-party filters.

T

thumbnail A small representation of an image used mainly for identification purposes in an image directory listing or, within Photoshop, for illustrating channels and layers. Thumbnails are also produced to accompany PictureCDs, PhotoCDs, and most 35-mm films submitted for processing.

TIFF (Tagged Image File Format) A standard and popular graphics file format originally developed by Aldus (now merged with Adobe) and Microsoft, used for scanned, high-resolution, bitmapped images and for color separations. The TIFF format can be used for black-and-white, grayscale, and color images, which have been generated on different computer platforms.

tile, tiling Repeating a graphic item and placing the repetitions side-by-side in all directions so that they form a pattern.

toolbox A set of programs available for the computer user, called tools, each of which creates a particular on-screen effect.

transparency Allows a GIF image to be blended into the background by ridding it of unwanted background color.

tween(ing) A contraction of "in-between." An animator's term for the process of creating transitional frames to fill in-between key frames in an animation.

typeface The term (based on "face"—the printing surface of a metal type character) describing a type design of any size, including weight variations on that design such as light and bold, but excluding all other related designs such as italic.

U

USB (Universal Serial Bus) A relatively recent interface standard developed to replace serial and parallel ports. It allows peripherals to be plugged and unplugged while the computer is switched on.

V

vector A mathematical description of a line that is defined in terms of physical dimensions and direction. Vectors are used in drawing packages (and Photoshop 6 upwards) to define shapes (vector graphics) that are position- and size-independent.

vector graphics Images made up of mathematically defined shapes, such as circles and rectangles, or complex paths built out of mathematically defined curves. Vector graphics images can be displayed at any size or resolution without loss of quality, and are easy to edit because the shapes retain their identity, but they lack the tonal subtlety of bitmapped images.

W

webpage A published HTML document on the World Wide Web, which when linked with others, forms a website, along with other files, such as graphics.

Web server A computer ("host") that is dedicated to Web services.

website The address, location (on a server), and collection of documents and resources for any particular interlinked set of webpages.

Windows Operating system for PCs developed by Microsoft using a graphic interface that imitated that of the Macintosh.

World Wide Web (WWW) The term used to describe the entire collection of Web servers all over the world that are connected to the Internet. The term also describes the particular type of Internet access architecture that uses a combination of HTML and various graphic formats, such as GIF and JPEG, to publish formatted text that can be read by Web browsers.

INDEX

BIBLIOGRAPHY AND USEFUL ADDRESSES

BOOKS

Digital imaging and photography

The Complete Guide to Digital Photography Michael Freeman *Silver Pixel Press* ISBN 1-883403-91-X

Digital Imaging for Photographers Adrian Davies & Phil Fennessy *Focal Press* ISBN 0-240-51590-0

Digital Photography: A Basic Guide to New Technology Jenni Bidner *Kodak Books* ISBN 0-87985-797-8

Real World Digital Photography Deke McClelland & Katrin Eismann *Peachpit Press* ISBN 0-201-35402-0

Start with a Digital Camera John Odam *Peachpit Press* ISBN 0-201-35424-1

Application-specific titles

Adobe Photoshop 6.0 for Photographers Martin Evening *Focal Press* Oxford 2001

Easy Adobe Photoshop 6 Kate Binder *Que* Indianapolis 2001

Paintshop Pro 7 in Easy Steps Stephen Copestake *Computer Step*, Southam (Warwickshire, UK) May 2001

Paintshop Pro 7 Explained N. Kantaris *Bernard Babani* (Publishing) London June 2001

WEBSITES

Note that website addresses can change, and sites can appear and disappear almost daily. Use a search engine to help you find new arrivals or check addresses.

Digital imaging and photography sites

The Complete Guide to Digital Photography **www.completeguidetodigitalphotography.com**

creativepro.com: news and resources for creative professionals **www.creativepro.com**

The Digital Camera Resource Page: consumer-oriented resource site **www.dcresource.com**

Digital Photography: news, reviews, etc. **www.digital-photography.org**

Digital Photography Review: products, reviews **www.dpreview.com**

ePHOTOzine **www.ephotozine.com**

The Imaging Resource: news, reviews, etc. **www.imaging-resource.com**

Photolink International: education in photography and other related fields **www.photoeducation.net**

photo.net: photography resource site—community, advice, gallery, tutorials, etc. **www.photo.net**

ShortCourses: digital photography: theory and practice **www.shortcourses.com**

SOFTWARE

Paintshop Pro **www.jasc.com**

PhotoImpact, PhotoExpress **www.ulead.com**

Photo-Paint, CorelDRAW! **www.corel.com**

Photoshop, ImageReady, Illustrator **www.adobe.com**

Photosuite **www.mgisoft.com**

Picture Publisher **www.micrografx.co**